MW00639795

IMAGES
*of America*

# THE BLACK HORSE PIKE

*from Katie*

12-25-17

*On the cover*: **BATEMAN MANUFACTURING COMPANY PROTEST, GRENLOCH, C. 1910.** Employees parody a patriotic display in their protesting an election at the Bateman Manufacturing Company in Grenloch. Some wear hats made from farm equipment parts they manufacture under the Iron Age brand. Others sport the Iron Age logo. See also page 36. (Courtesy of Jack Simpson.)

IMAGES
*of America*

# THE BLACK HORSE PIKE

Jill Maser

ARCADIA
PUBLISHING

Copyright © 2008 by Jill Maser
ISBN 978-0-7385-5678-9

Published by Arcadia Publishing
Charleston, South Carolina

Printed in the United States of America

Library of Congress Catalog Card Number: 2008920517

For all general information contact Arcadia Publishing at:
Telephone 843-853-2070
Fax 843-853-0044
E-mail sales@arcadiapublishing.com
For customer service and orders:
Toll-Free 1-888-313-2665

Visit us on the Internet at www.arcadiapublishing.com

*For those who prefer to take the slow road.*

# CONTENTS

# ACKNOWLEDGMENTS

The Black Horse Pike seems to be the dark horse in some unspoken road race, existing in the shadow of the squeaky clean White Horse Pike. But to those who live along it, work along it, and toil ceaselessly to preserve its history, the Black Horse Pike is a magnificent road—and home. And it is they, who willingly offered their expertise and images, whom I thank: Tom Bergbauer; Sue Carr; Suzanne E. Chamberlin; William Coxey; Mike DiMunno, South Jersey Rail Association (www.SJRail.com); Walt Ellis, Blackwood Lake Advisory Committee; Gloucester County Historical Society; Gloucester Township Historical Society; Bradley Green, the Collingswood Public Library; Bette Knipe; William W. Leap; Robert L. Long; John "Skip" Miller; Mark Plocharski; Pat Rappucci; Jack Simpson; Edward Taylor; Kay Taylor; Ed Thomas; Greg Vizzi, Atlantic County Parks and Recreation; Ed Werbany, Werbany Tire Town; Mike Williams, Delaware River Port Authority; and Deborah L. Wood.

Thank you, Erin Rocha, my editor, without whose flexibility and encouragement this book would not have been possible.

To my friends, for listening, thank you.

# INTRODUCTION

The Black Horse Pike might better be labeled "the road with many names." Once the Good and Convenient Road and the Camden and Blackwoodtown Turnpike, its names were at once helpfully descriptive, but also quite cumbersome in conversation and a cartographer's nightmare. Even today, the pike is a series of route numbers cutting a path through a dozen communities. Thanks to some enterprising real estate developers in the 1920s, the recognizable name took hold. (Note: due to the number of name changes both the pike and many of the area's communities have experienced over time, modern names are used throughout this volume.)

The images shown on the following pages will present how the Black Horse Pike and the communities that developed along its length have undergone significant growth and development. Perhaps their survival is a testament to the fortitude of the area's first settlers who made a living from the resources at hand and remained adaptable when facing both natural and man-made challenges.

The original inhabitants of southern New Jersey were the Leni-Lenape, a migratory people who traveled through the region's thick forests on the high ground following the course of waterways. Their paths connected a series of clearings, where they tended crops, and crossed the waterways where doing so would be predictable, above the high tide marks.

The earliest traces of the Black Horse Pike followed the contours of Big Timber Creek. Forged in the Leni-Lenape footpaths, the trail wended through Camden County from Gloucester City on the Delaware River to just beyond Blackwood.

The first European settlers found that following in the footsteps of the Leni-Lenape suited their needs quite conveniently. Clearings made ideal small farms and the seemingly endless forests were the source of the first industries in the region: lumber and its by-products, charcoal, and pine tar. The creek not only provided a convenient transportation route for the heavy shipments of lumber products, but once dammed, its waters were harnessed to power sawmills, gristmills, and fulling mills.

These successful settlers did not keep secrets about the fresh air, productive soil, and convenient location of their farms and businesses. Big Timber Creek became a busy waterway with flatboats hauling lumber and produce to market, and canoes and bateaus carrying new settlers and visitors alike to growing communities such as Runnemede, Chews Landing, and Blackwood.

But while boating along the creek was uncomplicated, crossing it was not. The Leni-Lenape crossed the creek above the high tide mark and the settlers followed suit. While these crossings were predictable, they were not convenient. Thus the building of a single bridge would reshape the region dependent upon Big Timber Creek.

Few bridges existed before the American Revolution, but in 1768, enough funds were raised to build a bridge at Chews Landing making crossing Big Timber Creek independent of the tides. Building the bridge was perhaps the first in a centuries-long string of events that shaped the Black Horse Pike and its communities.

Big Timber Creek slowly lost its significance as a transportation route and as traffic increased on the Black Horse Pike, so did the outcry for improvements. Some efforts were made, but public funds were minimal. Enterprising citizens formed turnpike companies and bought up the main

roads in the area. Tolls collected were spent on improving the roads. These early efforts helped to further increase traffic on the pike. Even public transportation took shape in the form of several competing stagecoach lines. But no matter how well improved or how well traveled the pike was, it still did not meet the needs of one manufacturer in Grenloch.

The Bateman brothers manufactured farming equipment. The heavy products were not easy to ship to market. Big Timber Creek was filling up with eroded soil from the farms that lined its banks. Horse-drawn wagonloads were likely to be mired in the muck on the pike. The Bateman Manufacturing Company needed an iron horse, and they got it from the Pennsylvania and Reading Railroad.

In 1891, the Grenloch branch was opened between Mount Ephraim and the loading dock of the Bateman Manufacturing Company. Passenger service was added along the line, and the Peanut Line, so named for its short route, served the region well for about 50 years.

Turnpikes and trains could not continue to meet the ever-changing needs of a burgeoning region. Train routes and schedules were inflexible, the pike remained in disrepair, and neither route continued to the shore. With a growing network of roads county governments saw the need for close oversight. Camden County purchased the Black Horse Pike from the turnpike company in 1903, and structural changes were made to the road.

Oversight and development of local roads came none too soon as a new-fangled contraption began to cruise them at increasing speeds. Cars were a passion, and everyone seemed to want one. Vehicles found commercial uses, too. Trucks moved products to the ports in Camden and to a growing number of local businesses. Public- and private-owned buses took the place of stagecoaches. Public service workers sped to emergencies in gas-powered fire engines, ambulances, and patrol cars. Change came quickly to the pike and the communities along it.

No longer were people tied to the center of their own town for work, shopping, and entertainment. Owning a car meant mobility and accessibility to widespread job opportunities and recreational outlets, including Blackwood Lake or the Jersey Shore.

With all this movement, big changes were needed to the pike. Not only did it need more improvements; it needed an identity. In 1923, at the urging of real estate developers in competition with White Horse Pike communities, the local government passed a resolution to extend the route to the shore and officially named it the Black Horse Pike. Improvements continued over the course of several years, including the installation of traffic control signals and the hiring of traffic officers. By 1929, the pike was paved between Camden and Chews Landing, and by 1931, the pike was extended beyond Williamstown and into Atlantic City.

The lakes along Big Timber Creek remained popular recreational areas despite the pike being opened to the shore. But not long after the pike was extended, two devastating floods threatened the tourism industry in Grenloch and Blackwood. In addition, the lakes were becoming polluted. The very development that provided a living for so many was ruining it. Blackwood Lake was condemned in 1960.

By this time, the pike towns were ensconced as suburbs of Philadelphia and survived the loss of tourism. With an increasing number of commuters, the two-lane Black Horse Pike had reached its traffic capacity. Plans were made for an expressway paralleling the pike and leading to Camden and quick passage to Philadelphia via the Ben Franklin Bridge. But as the construction project wended its slow way through the approval process, traffic volume also began to choke the Ben Franklin Bridge.

A second bridge was about to change the face of the Black Horse Pike. The Walt Whitman Bridge was the first step in a solution to traffic congestion that included completing the North-South Freeway and later, the Atlantic City Expressway. In 1965, the high-speed route from city to shore was complete.

Through three centuries of change, some meandering like Big Timber Creek and others as rapid as expressway traffic, the small towns along the Black Horse Pike continue to thrive. They are places where neighbors know one another, where new business owners are welcomed, where citizens are proud to live, and where the pike is still known as a good and convenient road.

# One

# BIG TIMBER CREEK

The first Europeans to arrive in Camden County made excellent use of the Leni-Lenape trails, clearings, and creek crossings. Big Timber Creek provided not only necessary water for crops and other basic needs but was the best source of transportation between settlements deep in the rich inland forest and the busy ports on the river.

Those who staked their claim along the banks of Big Timber Creek wrote enthusiastic accounts of the healthy air, productive soil, and accessibility to sea trade via the Delaware River, which attracted more settlement. By 1746, more than 3,500 people lived along Big Timber Creek.

These early settlers worked the forests and land. The creek was dammed at places, harnessing water power to operate sawmills, and later grist and fulling mills. Creek crossings were natural gathering places, and taverns were established upon them.

Farmers and lumbermen built fine homes and raised large families. The footpaths grew wider with use and the need to accommodate wagons and teams. Soon churches and schools were organized, raising buildings as funds permitted. Communities along the creek continued to grow with the addition of businesses, public services, and recreational outlets.

With that growth, came a shift in reliance on Big Timber Creek. While the creek remained important for both transportation and subsistence, overland travel was taking shape, and with it, the Black Horse Pike.

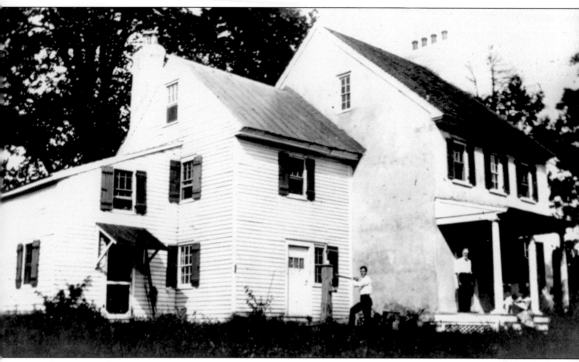

**No. 1009 Sycamore Avenue, Haddon Heights, c. 1920.** The house pictured here was built in three sections. The first section, that in the center, was built in 1699 on the Hinchman farm, probably as slave quarters. The view here is of the original back side of the house. The house faced the farm, but when the Black Horse Pike was surveyed, the building's orientation was changed to face the road. The small addition (left) was the second section to be built, and the large section (right) was added much later and has always been oriented to the pike. (Courtesy of William W. Leap.)

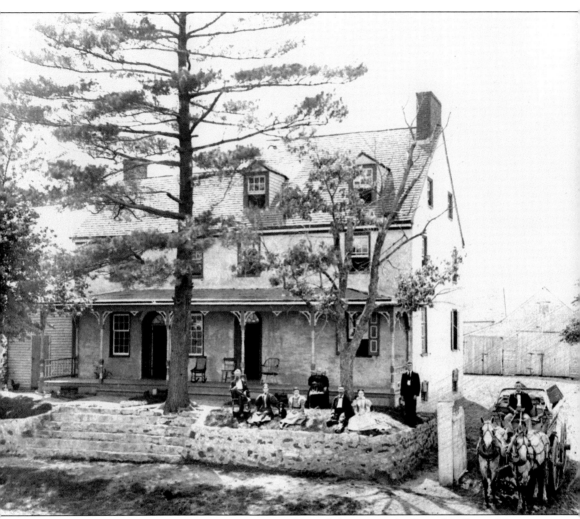

**DANIEL HILLMAN HOUSE, GLENDORA, 1892.** Although known as the Daniel Hillman House, the original portion of this residence, indicated by the left-most door and window, was built by John Richards in 1697 from stone cut from a quarry on his land. Located at Sixth Avenue on the Black Horse Pike, it was the first residence built in Glendora and is the oldest still standing in Gloucester Township (see page 100). By the time the Rowand family, pictured here, purchased the residence, the stone exterior had been covered, and the building tripled in size. (Courtesy of William W. Leap.)

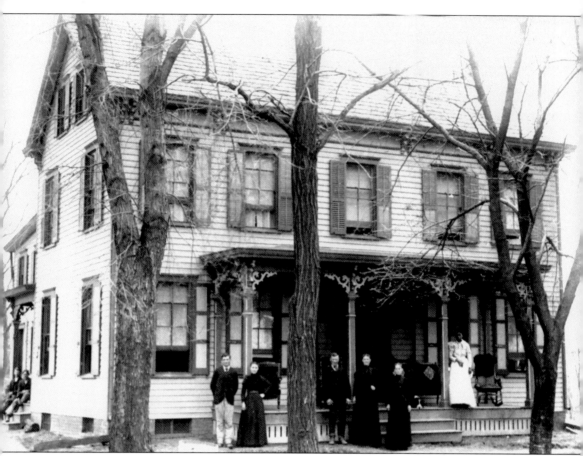

SICKLER HOUSE, CHEWS LANDING, C. 1880. The Sickler family and staff stands before their home on what had been the east end of the "S" curve on the Black Horse Pike. Joshua B. Sickler was a shopkeeper, blacksmith, and surveyor. In 1855, the post office was situated in his house, and he became postmaster. The house remains a private residence and is located across the old Black Horse Pike from St. John's Episcopal Church and across Chews Landing-Clementon Road across from the Chews Landing fire station. (Courtesy of William W. Leap.)

BIRTHPLACE OF AARON CHEW, CHEWS LANDING, C. 1890. Aaron Chew is perhaps Chews Landing's best known citizen, having been a tavern owner, Revolutionary War veteran, prisoner of war, and active civic leader. Chew was born in 1751 and at the age of 22 purchased what would become strategically important land. His 20 acres included the tavern and landing previously owned by Abraham Roe. Roe's Landing was situated at the intersection of the Black Horse Pike and Big Timber Creek, where in 1768, a bridge was built making the crossing one of the most important and best traveled in the region. Chew died in 1805 of yellow fever. (Courtesy of the Gloucester Township Historical Society.)

CHEW-POWELL HOUSE, BLENHEIM, C. 1980. Known now by the names of its various owners, this fine residence was built in the town then known as Upton. The Chew-Powell House, now a private residence located on Good Intent Road, is listed on both the New Jersey and National Registers of Historic Places. Adjacent to the property is the Chew-Powell-Wallens Burying Ground, which contains the remains of the area's early settlers, and also veterans of the Revolutionary and Civil Wars. (Courtesy of the Gloucester Township Historical Society.)

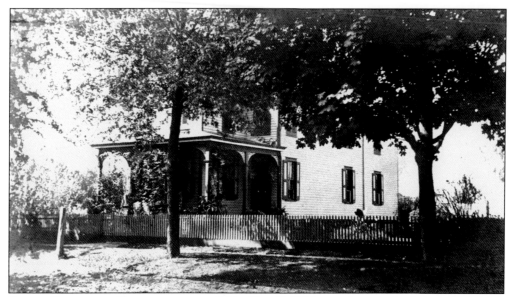

FIELDS RESIDENCE, BLACKWOOD, C. 1900. The Fields' house is typical of the comfortable dwellings built along the Black Horse Pike as residential development began. This grand home still stands between Garfield and Lincoln Avenues, minus the shade trees and inviting grounds. (Courtesy of Jack Simpson.)

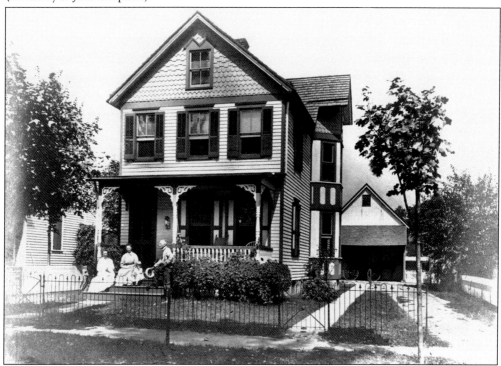

RESIDENCE, BLACKWOOD, C. 1890. This stately residence still stands on Central Avenue in Blackwood, just west of the Black Horse Pike. The family appears to be ready for an outing, as evidenced by the horse and carriage that stand at the ready in the outbuilding (right). (Courtesy of Jack Simpson.)

**MONIGAR HOME, BLACKWOOD, C. 1918.** The Monigar residence and farm stood south of Church Street on the Black Horse Pike. Residential farmers of this period grew a variety of herbs and vegetables. Apple, peach, and cherry trees were also typically found on farms. The Meadows Diner stands on this site today. (Courtesy of Jack Simpson.)

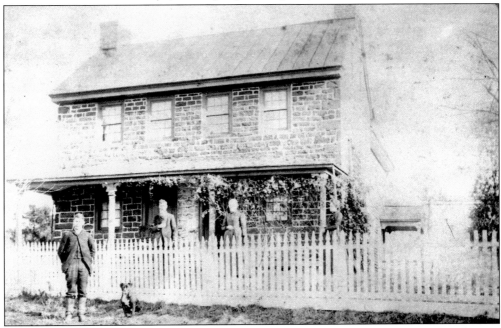

**ROBERT TURNER HOMESTEAD, TURNERSVILLE, C. 1900.** The Turner family settled in the area in 1798. Pictured here are Robert Turner's descendents, from left to right, Robert Turner Paulin (son of Jeremiah and Sarah), Jeremiah Hobson Paulin, Sarah Turner Paulin, and Mary M. Paulin (daughter of Jeremiah and Sarah). Turnersville, named for the family, is one of the communities that make up Washington Township. (Courtesy of the Gloucester County Historical Society.)

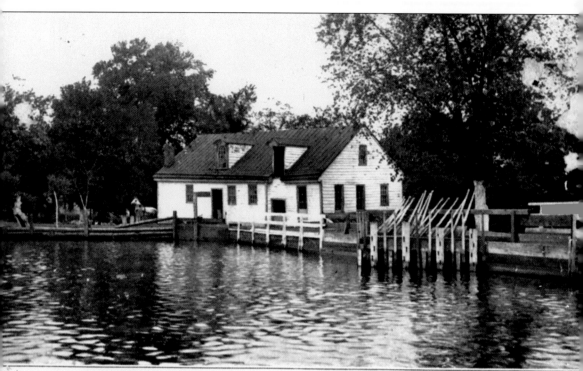

OLDE MILL, BLACKWOOD, N. J.                                    PHOTO. BY H. A.

YE OLDE MILL, BLACKWOOD, 1910. The forests provided for the area's first industry. Pine, chestnut, ash, and cedar blanketed interior New Jersey. The first sawmills were manpowered until the creek was dammed and water power harnessed. Logs and planks were floated downstream to the Delaware River, often destined for the fine furniture shops in Philadelphia. Some went for construction. This mill was built in 1859 after a fire destroyed Jonas Livermore's original mill. Solomon Preston purchased the property in 1880 and his factory, known as Ayer's Mill, manufactured horse blankets and carriage robes. Business got off to a good start, but by 1885, operations had ceased. (Courtesy of Suzanne E. Chamberlin and Deborah L. Wood.)

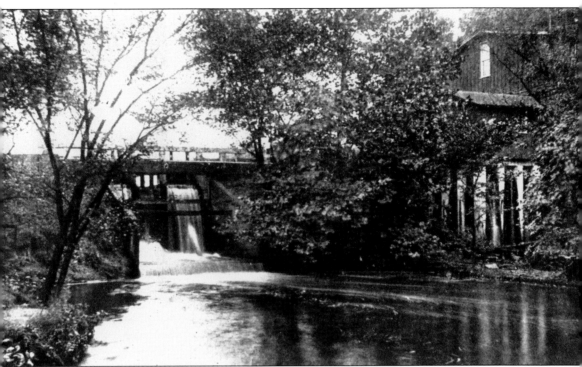

**GRENLOCH LAKE DAM, GRENLOCH, C. 1930.** Big Timber Creek was also dammed farther downstream forming Grenloch Lake. Stephen Bateman established his farming equipment manufacturing company on what was then called Spring Mills Lake. His Iron Age brand cultivators and other products were sold around the world. Under the auspices of Stephen's sons, Edward and Frank, the Bateman companies operated until about 1921. (Courtesy of Jack Simpson.)

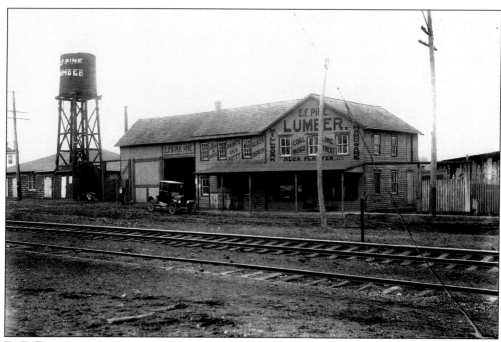

**E. F. PINE LUMBER, MOUNT EPHRAIM, C. 1920.** Until 1891, industrialists transported their products on Big Timber Creek or over the unpaved Black Horse Pike. The railroad offered a more profitable and reliable shipping option. Freight was moved on the Grenloch Branch of the Camden, Gloucester, and Mount Ephraim line, a rail line running parallel to the pike, for about 50 years. A short portion of the line is still in use between Bellmawr and Mount Ephraim. (Courtesy of Jim Laessle.)

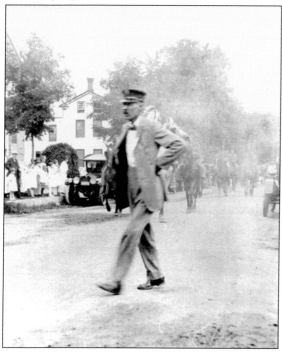

**E. FRANK PINE SR., BLACKWOOD, 1919.** E. Frank Pine, the owner of E. F. Pine Lumber, was an active member and also a benefactor of the Blackwood Fire Company. Here Pine leads World War I veterans in a homecoming and victory parade north along the Black Horse Pike toward Church Street in Blackwood. (Courtesy of Jack Simpson.)

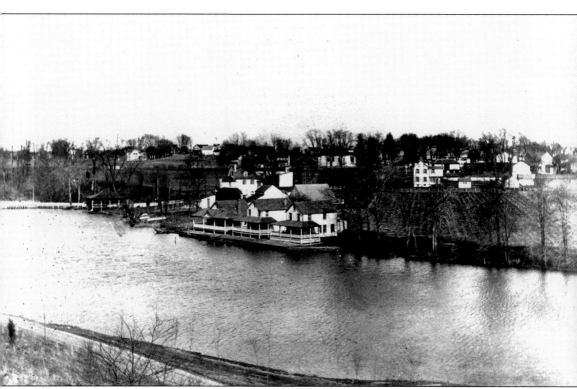

**Farms along Blackwood Lake, Blackwood, c. 1900.** The land cleared by the Leni-Lenape provided good foundations for farms. By 1701, a fulling mill was established in Blackwood, evidence that enough forest had been cleared to support sheep. The farmers, at first reliant upon the waterway for transportation, were soon conveniently situated between it and the Black Horse Pike, shown here at the top of the hill. (Courtesy of Jack Simpson.)

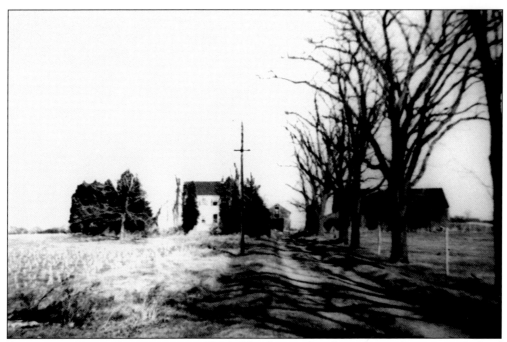

GRAISBERRY FARM, BLACKWOOD, C. 1900. The first settlers farmed out of necessity. As land was cleared by the lumbermen, more people farmed as an enterprise. Grain crops were planted, as well as vegetables well suited to the sandy soil of the region, including sweet potatoes and asparagus. Peach orchards were also a profitable undertaking. (Courtesy of the Gloucester Township Historical Society.)

FARM, BLACKWOOD, C. 1900. Farming remained a major industry in the Black Horse Pike towns well into the 20th century. Livestock and even turkeys were raised in addition to sturdy vegetable crops such as cabbages. As methods for transporting produce became better and faster and when on-site processing methods were developed and employed more, delicate produce such as tomatoes and blueberries gained a wider market. (Courtesy of Jack Simpson.)

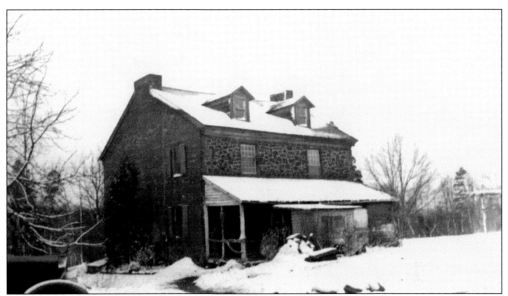

GABREIL DAVEIS TAVERN, C. 1920. One of the first anchors of a settlement was a tavern. Gabreil Daveis built his in 1756 on Big Timber Creek near Somerdale Road and served travelers along the waterway through Chews Landing. Daveis had a captive clientele until 1768 when the area's first bridge was built at Roe's Landing where the Black Horse Pike crosses the creek. The bridge shifted traffic patterns, causing Daveis's business to dwindle. The tavern building was privately owned until 1975, when William F. Schuck willed it and its spacious grounds to Gloucester Township. The building is rumored to be haunted and an annual ghost hunt is conducted around Halloween. (Courtesy of the Gloucester Township Historical Society.)

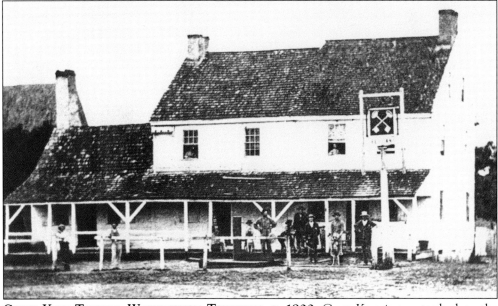

CROSS KEYS TAVERN, WASHINGTON TOWNSHIP, C. 1900. Cross Keys is a watershed, so the Cross Keys Tavern was conveniently located for business, as travelers from virtually all directions, following the waterways, would eventually pass through. Cross Keys is one of several communities comprising Washington Township. (Courtesy of the Gloucester County Historical Society.)

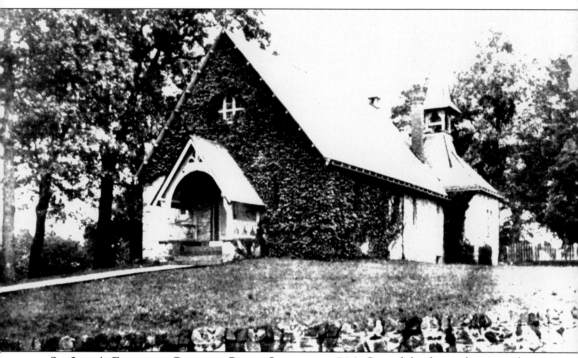

**St. John's Episcopal Church, Chews Landing, 1906.** One of the first indications that a settlement was a becoming a true community was the organization of a church. The process began in Chews Landing in 1789. An acre of land was donated by the Wetherill family of Burlington, but it was not until Aaron Chew solicited members of the young United States Congress that enough funds were collected to build a structure. The original two-story, red cedar church was built in 1791. The cornerstone for the stone church was laid in 1880, and cedar from the original church building was used in the construction of the carriage sheds. A historical marker stands outside the church and reads "Birthplace of Lt. Aaron Chew, December 19, 1751—Sept. 23, 1805. Soldier and patriot. Served with distinction in Gloucester County Militia in Revolutionary War. Captured by British while home on leave and confined in prison ship at Fort Lott, NY. Lies buried in the graveyard of this church, St. John the Evangelist." (Courtesy of the Gloucester Township Historical Society.)

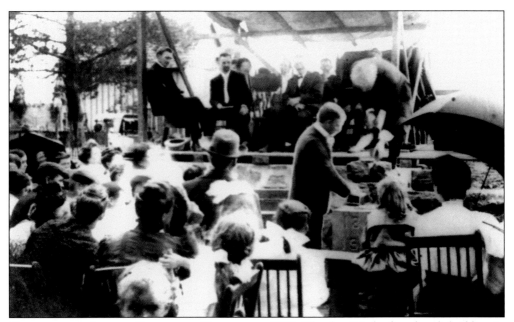

**CORNERSTONE LAYING CEREMONY, GLENDORA, 1912.** The first Methodist church building in Glendora was small and a long time in construction, but as the congregation grew and raised funds, larger buildings were warranted. Here members of the congregation attend a ceremony laying the cornerstone of the fourth Chews Methodist Church building located on the Black Horse Pike just south of Station Avenue. (Courtesy of the Gloucester Township Historical Society.)

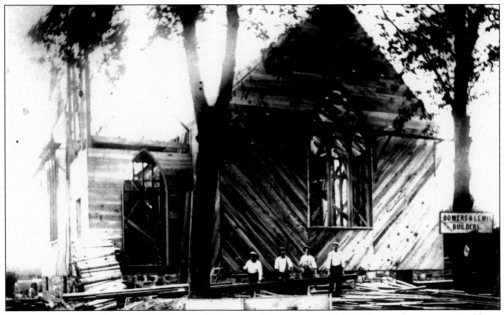

**REBUILDING THE CHEWS METHODIST CHURCH, GLENDORA, 1912.** The workmen pictured here are building the fourth Chews Methodist Church. John H. Bowers Jr., proprietor of Bowers and Lewis Builders, the company constructing the church, was elected the first mayor of Runnemede in 1926. (Courtesy of the Gloucester Township Historical Society.)

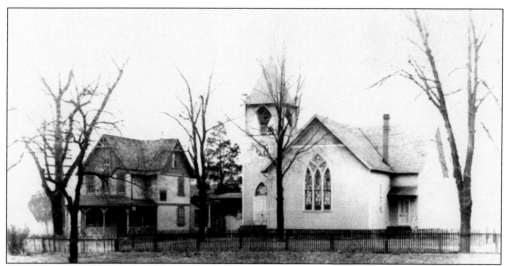

**CHEWS METHODIST CHURCH AND PARSONAGE, GLENDORA, 1913.** Construction of the Chews Methodist Church on the Black Horse Pike between Station Avenue and Front Street is now complete. The parsonage (left) was built in 1890. (Courtesy of the Gloucester Township Historical Society.)

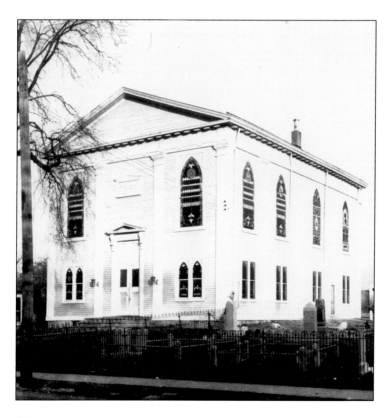

**METHODIST CHURCH, BLACKWOOD, 1941.** The Methodist congregation in Blackwood initially met outdoors and in private residences. As the congregation grew, services moved to the schoolhouse. In 1834, a church was built and served until 1856, when this two-story frame church was built on East Church Street, just east of the Black Horse Pike. (Courtesy of Suzanne E. Chamberlin and Deborah L. Wood.)

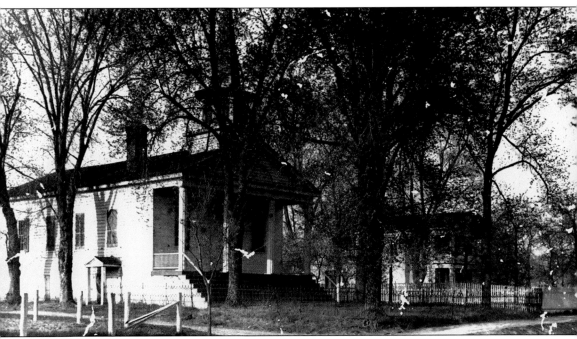

BAPTIST CHURCH, BLACKWOOD, C. 1920. The Baptist Church of Blackwoodtown was organized in 1847. The small congregation initially met in Blackwood's Methodist church until it grew in size to warrant its own building. Services were moved to a structure built as a meeting house by the founder of the mill on Blackwood Lake. A year later, the church building was moved to its permanent location at Baptist Lane and West Church Street near the center of Blackwood. (Courtesy of Jack Simpson.)

**MOUNT EPHRAIM HOTEL, MOUNT EPHRAIM, C. 1920.** The second generation of guest housing began to spring up in the late 19th century in the form of hotels. Larger than taverns or inns, hotels such as the Mount Ephraim Hotel accommodated a number of guests in private rooms. Mount Ephraim Hotel is strategically located between Camden and early settlements along what is now the Black Horse Pike and also on the east-west Kings Highway between Gloucester City, Woodbury, and Haddonfield. (Courtesy of William W. Leap)

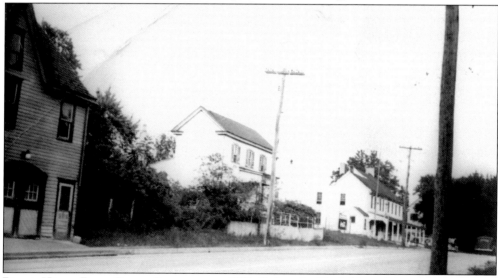

**BLACK HORSE PIKE, CHEWS LANDING, C. 1910.** Before the Black Horse Pike was straightened and made to pass just west of the old village of Chews Landing, the road wended by "S" curve over Big Timber Creek and continued south to Blackwood. Travelers on that route passed, from left to right, the Chews Landing Fire House; the home of Helen Merkel, former township historian; and the Chews Landing Hotel. Only the fire house remains standing. (Courtesy of the Gloucester Township Historical Society.)

IRA BRADSHAW LEAP, CHEWS LANDING, c. 1880. Born in 1831, Ira Bradshaw Leap held the license to operate the Chews Landing Hotel from June 31, 1884, until his death on April 2, 1890. (Courtesy of William W. Leap.)

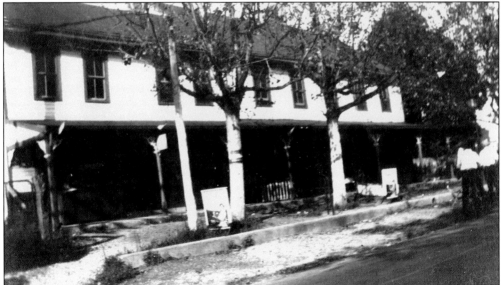

CHEWS LANDING HOTEL, CHEWS LANDING, 1901. The Chews Landing Hotel was located in the village of Chews Landing on the "S" curve portion of the Black Horse Pike, now Chews Landing-Clementon Road. The back of the hotel would have faced Big Timber Creek, offering fine views and access to canoeing for guests. The Chews Landing Fire Company building now occupies this location. (Courtesy of William W. Leap.)

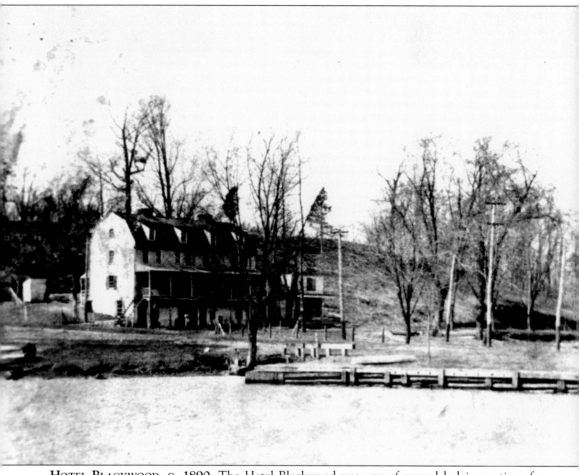

**HOTEL BLACKWOOD, C. 1890.** The Hotel Blackwood was one of several lodging options for vacationers at Blackwood Lake. The hotel offered fine views eastward across the lake and toward Blackwood. Hotels of the day offered meals, baths, and other services to guests. (Courtesy of Jack Simpson.)

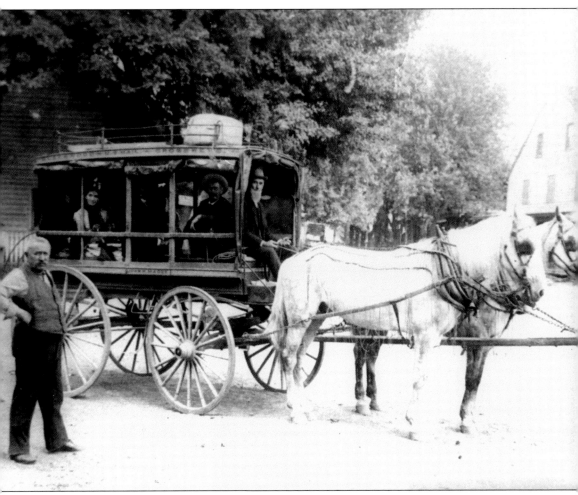

**MAGEE STAGECOACH AND MAIL WAGON, MOUNT EPHRAIM, 1897.** Stagecoaches, the precursors to buses, had their heyday through a good portion of the 19th century. The rides were probably increasingly convenient as competing lines sprang up to service growing populations along the Black Horse Pike, but travel could not have been comfortable. The driver sports a bandana to protect himself from road dust. John Magee's mail wagon is pictured here near the Mount Ephraim Hotel (right) and its lettering reads, "Blackwood U.S. Mail Cross Keys" (Courtesy of the Gloucester Township Historical Society.)

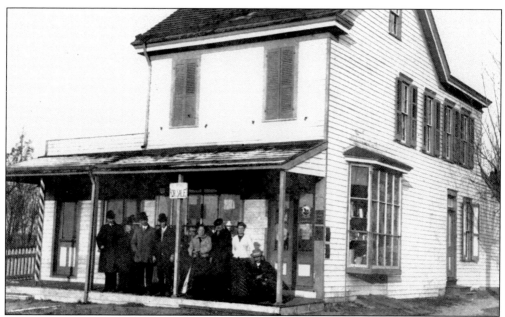

**SOLNEK STORE AND BARBER SHOP, GLENDORA, 1911.** Stores were another sign of an established community. Merchants stocked all the necessities in one large showroom. Pictured here is the Solnek family on the porch of the store and barber shop they built in 1888 on the Black Horse Pike at Seventh Avenue in Glendora. The building is for sale and was sold in 1911 to Mr. Naphas (see image below). (Courtesy of William W. Leap.)

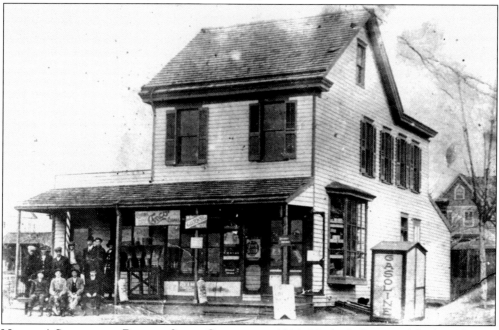

**NAPHAS' STORE AND BARBER SHOP, GLENDORA, 1911.** Naphas's Store and Barber Shop is open for business on the pike at Seventh Avenue in Glendora and has collected quite a crowd. Gasoline is now also for sale, as are soft drinks and two different brands of butter. (Courtesy of William W. Leap.)

**DIXON'S STORE, GLENDORA, 1910.** Development along some roads might be marked by simple items such as the gas light outside Dixon's Store at Station Avenue and the Black Horse Pike in Glendora. The business of real estate development had begun, as indicated by the billboard in front of the store that reads "Glendora . . . Lots for Sale . . . $1.00 per week" (Courtesy of the Gloucester Township Historical Society.)

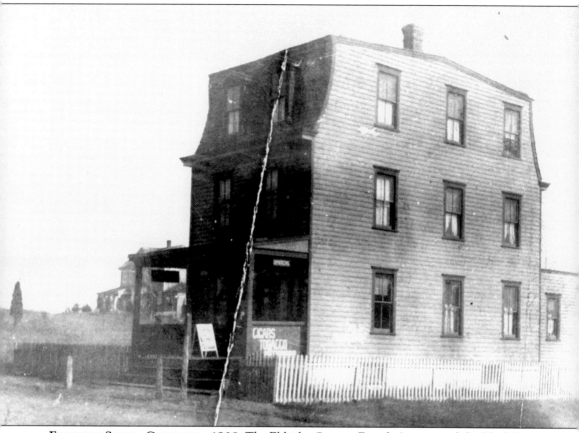

ELDRIDGE STORE, GLENDORA, 1908. The Eldridge Store at Fourth Avenue and the Black Horse Pike in Glendora carried not only necessities of the day, but signs on the front porch indicate that cigars, tobacco, and notions were also sold. The Eldridge Store may have set itself apart from others in the others in the area by offering oysters for sale. (Courtesy of the Gloucester Township Historical Society.)

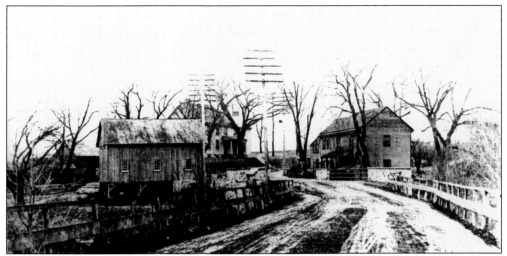

**PRICE'S STORE, CHEWS LANDING, 1913.** Price's Store is pictured here on the right side of the "S" curve in the Black Horse Pike just across the bridge over Big Timber Creek. Across the road from the store are the Brewer residence and outbuildings. The Brewer family was prominent in Chews Landing, making their living as merchants, transporters of goods, and shipbuilders. (Courtesy of the Gloucester Township Historical Society.)

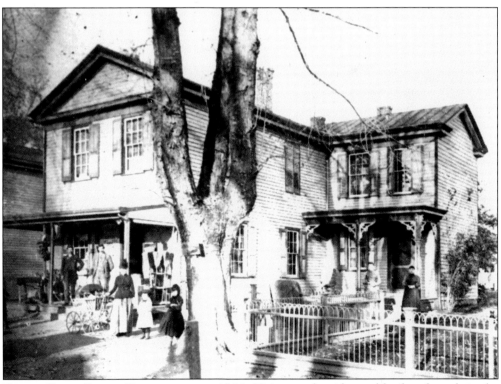

**EDGAR COLES STORE, BLACKWOOD, C. 1900.** Visitors and residents alike found goods in the Coles store, which became Simpkins Feed Store in 1904, and services such as the telephone, which was introduced as a public service in Blackwood in 1900. (Courtesy of the Gloucester Township Historical Society.)

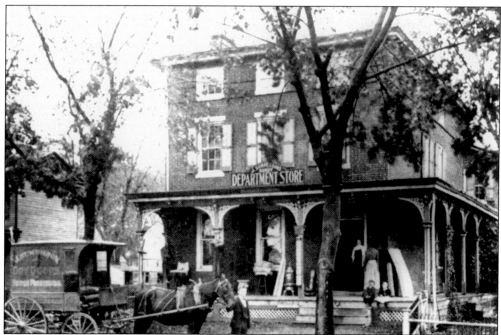

**J. Summerson's Handy Department Store, Blackwood, c. 1900.** J. Summerson offered delivery in addition to selling goods at his large department store on the Black Horse Pike. This building was later converted into a bakery and also a doctor's office and residence. (Courtesy of the Gloucester Township Historical Society.)

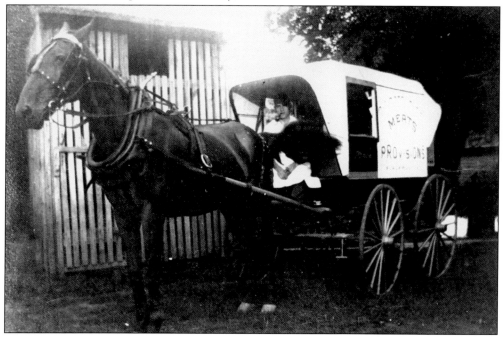

**Batchelor's Vendor Wagon, c. 1900.** Some merchants sought their market niche through home delivery. Mr. Batchelor's wagon and his black horse certainly traveled the pike to deliver meats and provisions to the residents of Blackwood. (Courtesy of Jack Simpson.)

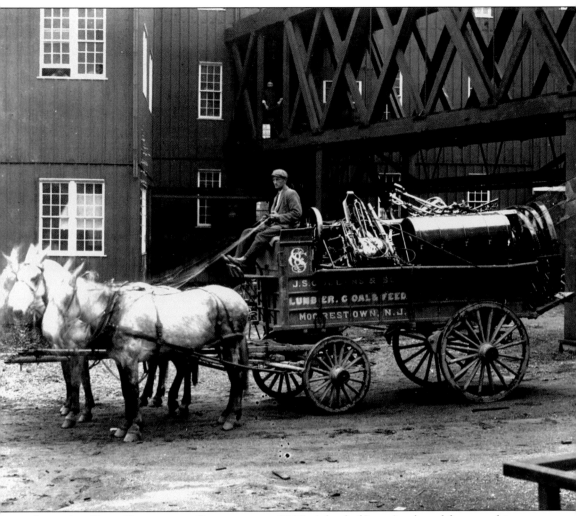

IRON AGE FARM EQUIPMENT, GRENLOCH, C. 1900. A load of Iron Age brand farm machinery manufactured by the Bateman Manufacturing Company is ready for transport by the three-mule team of J. S. Collins and Son of Moorestown, New Jersey. Transporting heavy machinery over the sandy soil of local roads such as the Black Horse Pike must have been difficult. Major improvements to the pike would not be made until the 1920s. (Courtesy of Jack Simpson.)

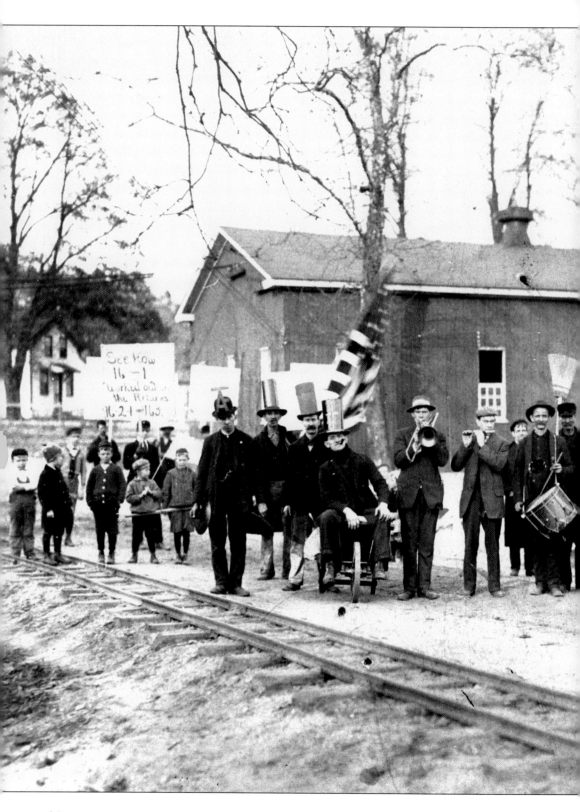

**PROTEST AT BATEMAN MANUFACTURING COMPANY, GRENLOCH, C. 1910.** The Bateman Manufacturing Company was founded in 1860 by Stephen Bateman. The company manufactured cultivators and other farm implements under the brand name of Iron Age. A small town developed around the business, which included employee housing, a blacksmith's shop, and a mercantile. Later Stephen Bateman's sons, Edward and Frank, tried their hand at manufacturing automobiles (see page 81). Frank was instrumental in the extension of the Camden, Gloucester and Mount Ephraim Railway directly to his plant. In this image, it appears that employees are protesting an election. The sign at left reads "See how 16-1 worked out in the returns. 16-2-1=163." (Courtesy of Jack Simpson.)

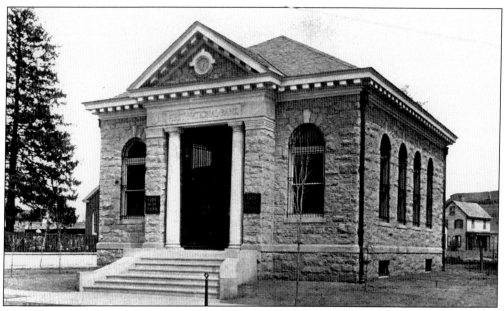

**FIRST NATIONAL BANK, BLACKWOOD, C. 1909.** As communities and their populations grew, so did the service industry. The First National Bank of Blackwood, located at the southeast corner of Church Street and the Black Horse Pike, opened its doors in December 1909 with assets of $6,100. (Courtesy of Jack Simpson).

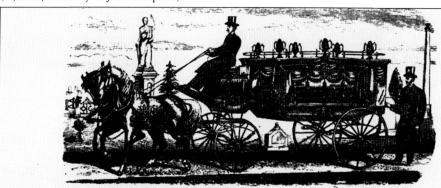

# WILLIAM P. BUCK,
# UNDERTAKER
## WILLIAMSTOWN, N. J.

☞BODIES PRESERVED WITH OR WITHOUT ICE.
FOLDING CHAIRS FURNISHED.

**UNDERTAKER'S ADVERTISEMENT, WILLIAMSTOWN, 1889.** William P. Buck advertises his complete line of services available in Williamstown. (Courtesy of the Gloucester County Historical Society.)

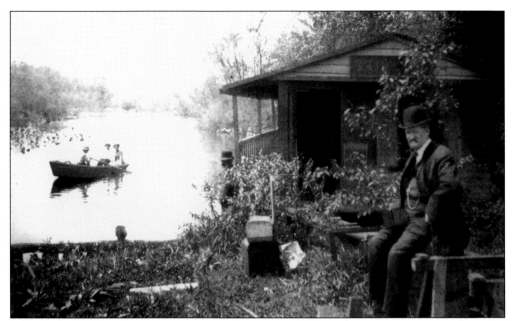

BOATHOUSE ROW, CHEWS LANDING, C. 1880. As towns began to grow up along Big Timber Creek, so did the number of visitors seeking respite from the dirty, crowded cities of Philadelphia and Camden. Vacations along the north branch of Big Timber Creek in Chews Landing included plenty of fresh air, sunshine, and canoeing. (Courtesy of the Gloucester Township Historical Society.)

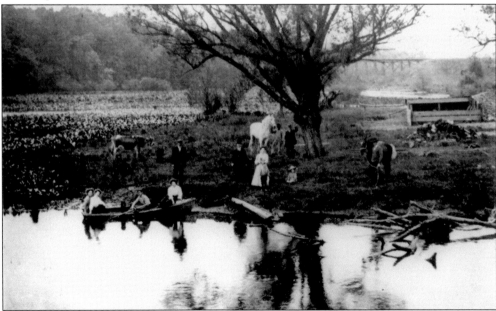

CANOEING ON BIG TIMBER CREEK, CHEWS LANDING, C. 1880. This view from the Black Horse Pike looks across Big Timber Creek and toward Somerdale Road. While visitors enjoyed their vacation in the fresh air along the creek, permanent residents continued to use it for trade and transportation and for a farm's many needs. (Courtesy of the Gloucester Township Historical Society.)

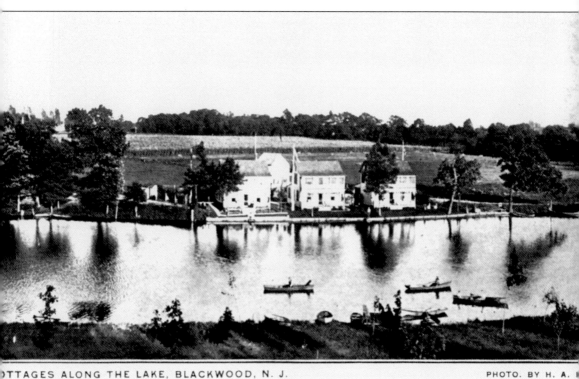

)TTAGES ALONG THE LAKE, BLACKWOOD, N. J.                              PHOTO. BY H. A.

COTTAGES ON BLACKWOOD LAKE, BLACKWOOD, C. 1900. Blackwood Lake was one of many popular recreational areas around the beginning of the 20th century. While the permanent population of Blackwood and other towns along the pike had yet to boom, vacationers from the cities of Philadelphia and Camden were drawn to the recreational activities and spacious guest cottages situated along the banks of the lake. (Courtesy of Suzanne E. Chamberlin and Deborah L. Wood.)

CAMDEN COUNTRY CLUB, BLACKWOOD, C. 1925. A club such as this one offered more intimate accommodations than a hotel; probably much like today's bed and breakfasts. This building is a private residence located on Marshall Avenue in Blackwood. (Courtesy of Jack Simpson.)

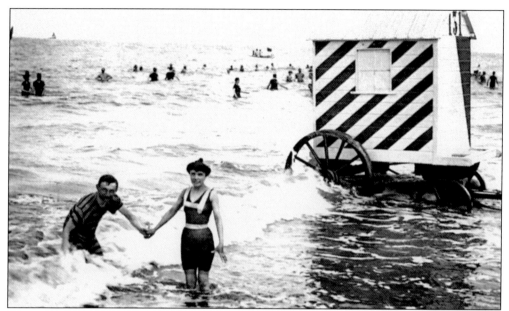

WHEELED BATH HOUSE, ATLANTIC CITY, C. 1900. Atlantic City was first touted as a health resort and developed quickly into a popular destination. Railroads were quick to respond and competing lines opened in the 1850s along either side of the White Horse Pike reducing the trip from city to shore to a few short hours. The White Horse Pike remained the only direct route from Camden to Atlantic City until the Black Horse Pike was extended past Williamstown in 1931. (Author's collection.)

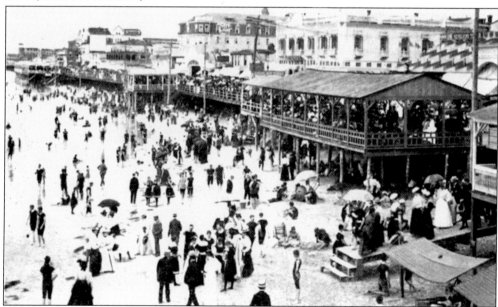

NEW YORK AVENUE, ATLANTIC CITY, C. 1880. The popularity of Atlantic City as a destination grew with each passing year. Enormous hotels and amusement piers offered attractions found nowhere else. After the advent of the automobile, travelers hoping to reach Atlantic City via the Black Horse Pike found a sudden end to the road in Williamstown and were forced to wend their way over dirt roads to the White Horse Pike to continue on to the shore. (Author's collection.)

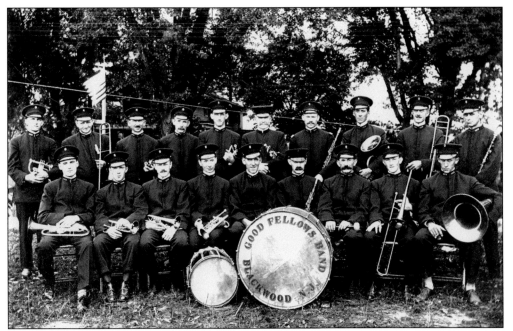

**GOOD FELLOWS BAND, BLACKWOOD, C. 1926.** As the communities along the Black Horse Pike matured, they found new ways to attract and entertain visitors. The Good Fellows Band was a community mainstay, performing at major functions, marching in parades, and raising funds for community causes. Here the band poses on the knoll on the pike at Lake Avenue. (Courtesy of Jack Simpson.)

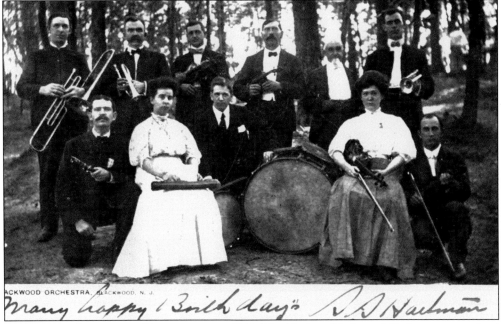

**BLACKWOOD ORCHESTRA, BLACKWOOD, C. 1910.** The 10-piece Blackwood Orchestra entertained vacationers at the Blackwood Lake resort area, launching a long tradition of outdoor performances that continues to this day. (Courtesy of Suzanne E. Chamberlin and Deborah L. Wood.)

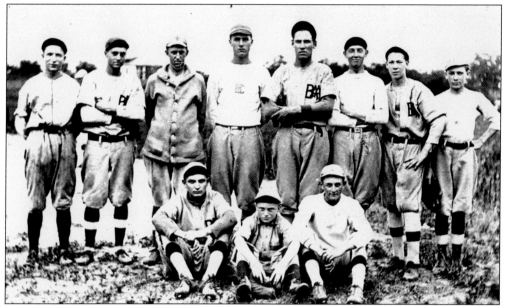

BLACKWOOD BASEBALL TEAM, BLACKWOOD, C. 1922. Organized athletics were popular in towns along the pike. Members of the Blackwood Athletic Association's baseball team are, from left to right, (first row) Elm Swantz, Joe Prickett, and Josh Clowd; (second row) Joe Brogan, Vince Spina, Link Williams, Frank Keith, Herb Keith, Elvin Sees, Hap Hawkey, and Howard Roth. (Courtesy of Jack Simpson.)

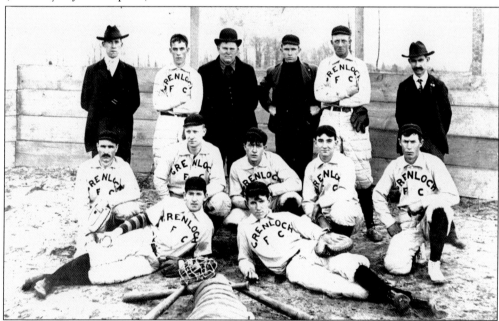

GRENLOCH BASEBALL TEAM, GRENLOCH, C. 1920. Baseball and football were popular outdoor pastimes for young men living in towns along the Black Horse Pike. Hometown pride and the fraternity of competition were certain to have formed rivalries, especially between towns in as close proximity as Grenloch and Blackwood. Here the unidentified members of the Grenloch Field Club's baseball team pose with their rather intimidating managers. (Courtesy of Jack Simpson.)

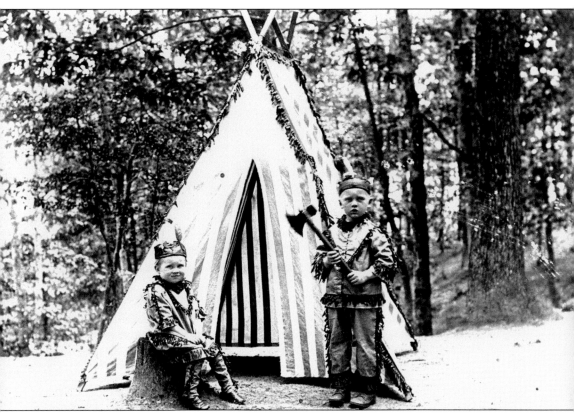

**CELEBRATING NEW JERSEY'S HERITAGE, BLACKWOOD, C. 1910.** Two young boys take part in summertime festivities near Blackwood Lake dressed to honor the first inhabitants of the region, the Leni-Lenape. Celebrations along the lake were enthusiastic and well attended by residents and guests alike. Concerts, dancing, and canoe races entertained guests at bunting-bedecked lodging houses along the lake shores. (Courtesy of Jack Simpson.)

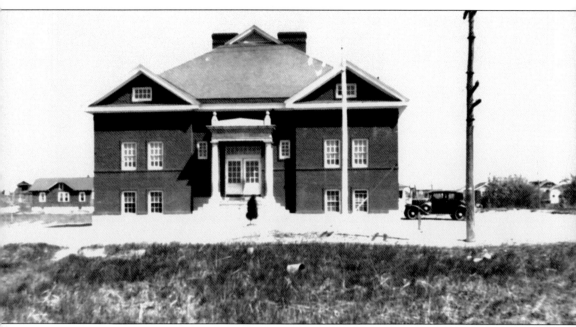

GLENDORA SCHOOL, GLENDORA, C. 1924. Growing communities required public services. The earliest schools were supported by private funds, with classes taught by itinerant teachers in private homes, storerooms, or even outdoors. Equal opportunity in education was first sought in 1829 with the Act to Establish Common Schools. With passage of the act, access to education was required and schools were needed. Before this school was built, children living in Glendora attended school in Chews Landing. Construction of the original building was completed in 1922 and the capacity of the four-room brick schoolhouse was quickly outgrown. The school was expanded in 1931, 1951, and 1952. A final addition was completed in 1978. The school building stands on Station Avenue just off the Black Horse Pike. (Courtesy of William W. Leap.)

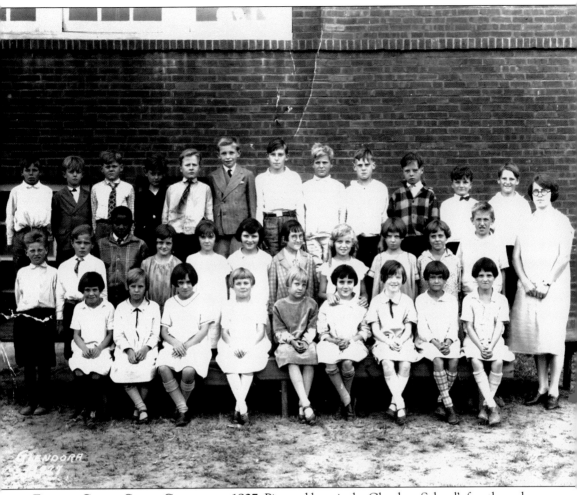

**FOURTH GRADE CLASS, GLENDORA, 1927.** Pictured here is the Glendora School's fourth grade class, taught by Minerva Chew Glover. Identified are Mary Stoul, Alice Wiley, Rhoda Young, Eleanor Webb, Marguerite Quinten, Grace Marshall, Anna Hinkle, Grace Griffin, Alice Bayer, Russen Newsom, Joe Conaway, Abim Cadwell, Dorothy McGinty, Bette Lambert (Knipe), Alice Hargan, Elsie Morisson, Lib Naphas, Dorothy Hamefield, Eva Stewart, Billy Capen, Stanley Stamford, Parker ?, Tammy Robertson, Harry Shisler, James Parker, Al McKnight, Johnny Sparks, Charles Schaffer, Jack Heft, Arthur Hizer, and Richard Cook. (Courtesy of Bette Knipe.)

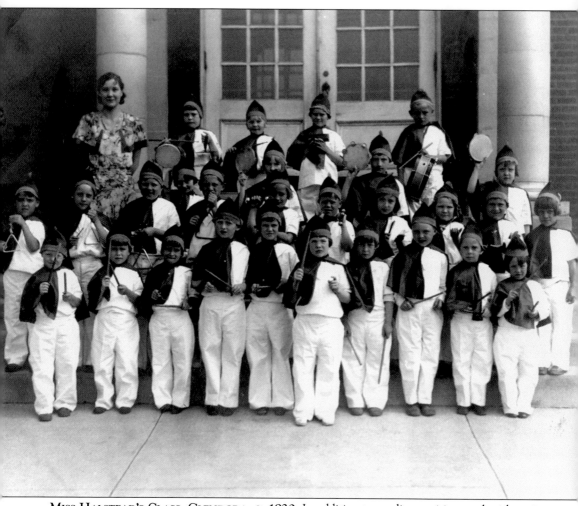

**MISS HALSTEAD'S CLASS, GLENDORA, C. 1930.** In addition to reading, writing, and arithmetic, students in Glendora were taught music. Here Miss Halstead's Glendora School class is ready to perform on their drums, tambourines, and other rhythm instruments. (Courtesy of Bette Knipe.)

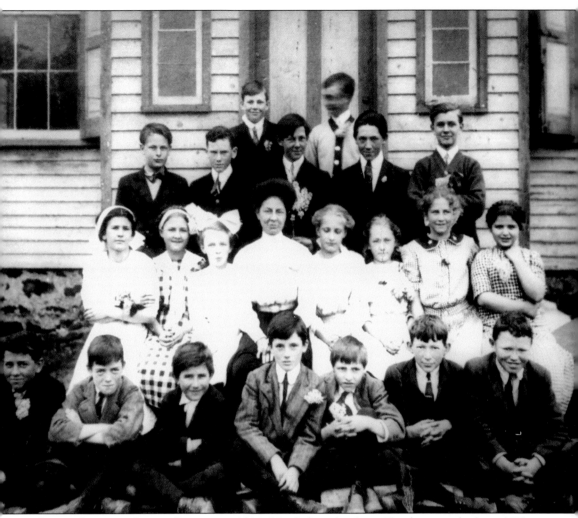

CHEWS SCHOOL, CHEWS LANDING, 1911. Until the school in Glendora was built in 1922, students from that community attended the Chews School. From left to right are (first row) Edmund Best, Horace Maguire, Ralph Riley, Leroy Beans, unidentified, ? Fish, and George Allibone; (second row) Anna Frazer (Mrs. L. Parsons), Helen Wilson (Mrs. L. Riley), Matilda Clark, teacher Miss Ellis or Miss Tighe, Margaret Phillpot (Mrs. W. Taylor), Ethel Wheeler, Birtha Zane, and Edna Davis; (third row) Sickler Entriken, Leon Parsons, Ed Wilson, Claude ?, and Bernard Galbiarth; (fourth row) Ed Beck and Raymond Beans. (Courtesy of the Gloucester Township Historical Society.)

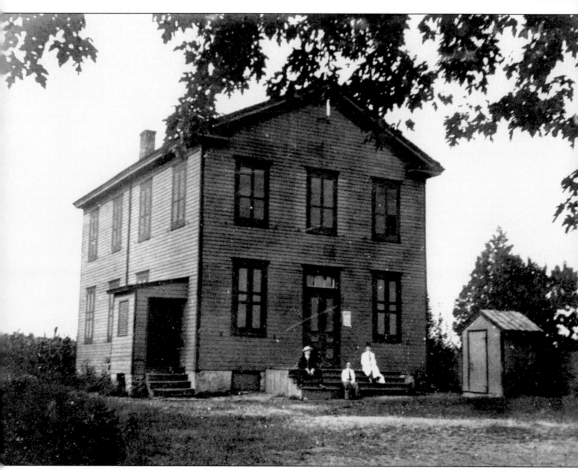

BLACKWOODTOWN SCHOOL, BLACKWOOD, C. 1900. As public education continued to reshape itself school districts were formed and officials appointed to oversee the process and outcomes. Of the 11 teachers in the Gloucester Township school districts, two were assigned to the Blackwoodtown School. This impressive two-story school with outbuilding was built in 1871. The school was moved from its original location to make room for the municipal building. It is now a private residence on East Church Street in Blackwood. (Courtesy of Jack Simpson.)

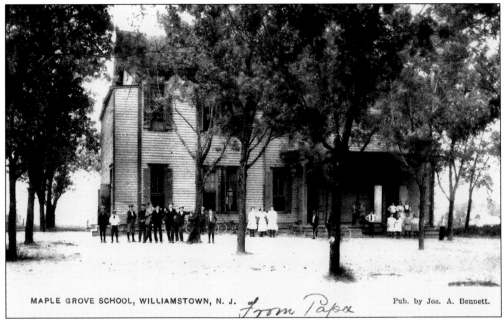

MAPLE GROVE SCHOOL, WILLIAMSTOWN, N. J. *From Papa*    Pub. by Jos. A. Bennett.

MAPLE GROVE SCHOOL, WILLIAMSTOWN, C. 1900. This schoolhouse was built in 1872 in Williamstown. The town was first known as Squankum, the Leni-Lenape name for Place of Evil Ghosts, and changed its name in 1841. Several glassworks opened in Williamstown in the mid-19th century, and the town's population grew quickly, creating the need for more services, including a new school. (Courtesy of the Gloucester County Historical Society.)

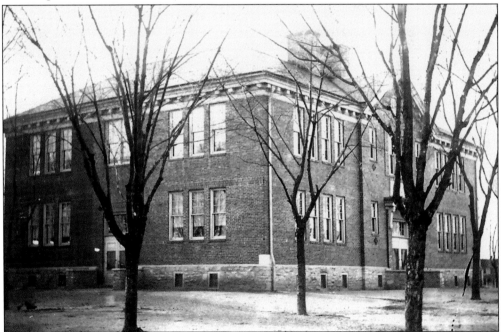

NEW MAPLE GROVE SCHOOL, WILLIAMSTOWN, C. 1910. As the population demanded, the New Maple Grove School was built in 1909 at a cost of $23,000. The sturdy brick building contained eight classrooms. (Courtesy of the Gloucester County Historical Society.)

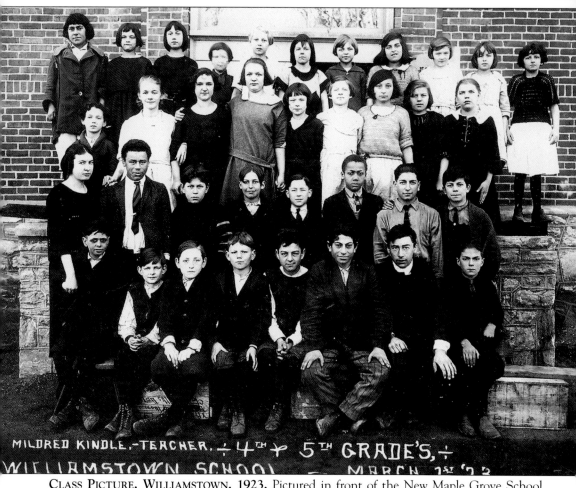

**CLASS PICTURE, WILLIAMSTOWN, 1923.** Pictured in front of the New Maple Grove School are the combined fourth and fifth grade classes. The students' teacher is Mildred Kindle (left, second row). (Courtesy of the Gloucester County Historical Society.)

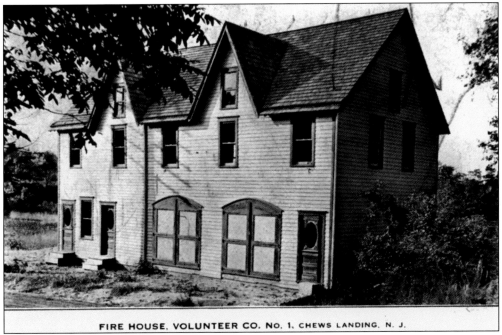

FIRE HOUSE, VOLUNTEER CO. NO. 1, CHEWS LANDING, N. J.

VOLUNTEER FIRE COMPANY NO. 1, CHEWS LANDING, C. 1900. Public safety services also began to organize as populations grew. With most structures built of wood and heated by fireplaces, the ability to fight fires was important. The Chews Landing Fire Company was established in 1909. This building located on the "S" curve of the pike remained in service until 1948 when the new brick station was built at the intersection of Somerdale Road and the Old Black Horse Pike. The building pictured here has been converted into apartments. (Courtesy of the Gloucester Township Historical Society.)

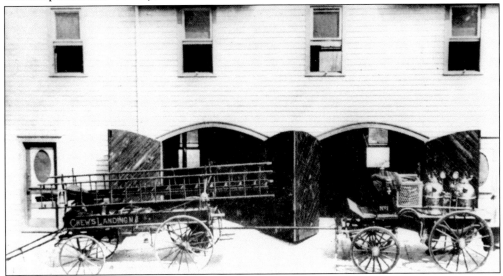

FIREFIGHTING EQUIPMENT, CHEWS LANDING, C. 1910. The first fire trucks were flatbed trucks drawn by a team of horses or even the men of the company. The Chews Landing Fire Company No. 1 purchased its first motorized equipment in 1918. (Courtesy of the Gloucester Township Historical Society.)

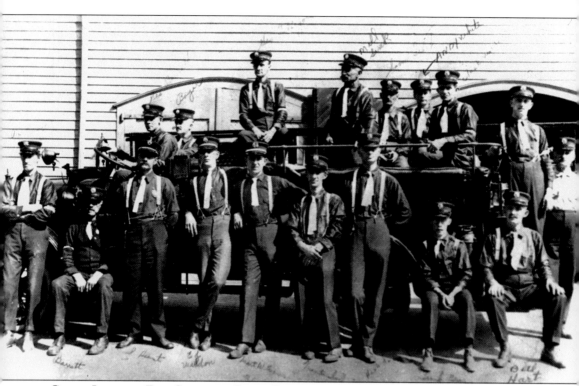

**CHEWS LANDING FIRE COMPANY, CHEWS LANDING, C. 1918.** Members of the Chews Landing
Fire Company pose on their new, motorized fire truck. Members are, from left to right, (first row)
William Lillagore, ? Barrett, Seymore Hunt, Ed Weldon, Mart Williams, Harry Mendenhall,
Herb Free, Frank Beans, and Bill Hart; (second row) George Barrett, Howard Boyer, George
Lillagore, Mill Sink, Sam Sink, Andy White, Clark Walton, Thomas Sparks, and Bill Clark.
(Courtesy of William W. Leap.)

THE PIKE AS A MAIN STREET, BLACKWOOD, C. 1919. Community development gradually shifted focus away from Big Timber Creek and to the Black Horse Pike. As early as 1820, citizens demanded improvements to the roadway. The best technologies of the day were applied; a solid roadbed was built, and an arched surface developed to keep the road as dry as possible. Commercial and residential construction was clustered around major intersections forming town centers. In this image, an unidentified veteran of World War I and his mount prepare to participate in the World War I homecoming parade on the pike in Blackwood. Black Horse Pike towns have a long tradition in military service with men having proudly served in every war since the American Revolution. (Courtesy of Jack Simpson.)

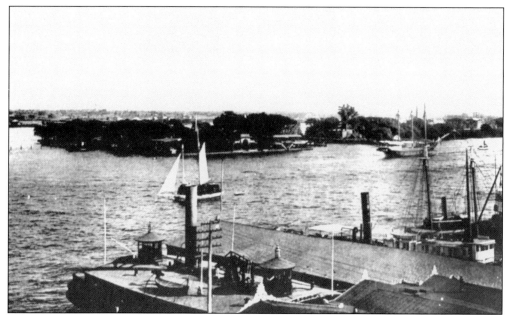

FERRY STATION AND PORT, CAMDEN, C. 1900. The Delaware River was a busy commercial avenue in the days before railroads, highways, and airports. As the city of Philadelphia grew, shipping lanes between New Jersey and Philadelphia shifted north from Gloucester City to Camden. The course of the Black Horse Pike shifted, too, and veered away from Big Timber Creek in order to connect with this bustling port. The course of the pike remains virtually unchanged since Camden developed as the connection to Philadelphia. (Courtesy the Collingswood Public Library.)

FERRY STATION, CAMDEN, C. 1900. While improvements were being made to the Black Horse Pike, travelers, merchants, manufacturers, and farmers continued to face the challenge of crossing the Delaware River. Ferries operated frequently, and the trip between Camden and Philadelphia was short, but any number of obstacles could prevent a smooth crossing. Government officials in both Pennsylvania and New Jersey proposed fixed river crossings as early as 1818. (Courtesy the Collingswood Public Library.)

CAMDEN AND BLACKWOODTOWN TURNPIKE, GLENDORA, C. 1880. Despite a solid roadbed and arched surface, the unpaved Black Horse Pike could not have been easy to travel, particularly in foul weather or with a heavy load of cargo. The sandy soil turned muddy with rain and was quick to freeze solid in winter. The pike was also dotted with steep hills requiring significant effort on the part of the horses or mules. The wagon driver pictured here is traveling south past a residence that still stands at Seventh Avenue in Glendora. (Courtesy of William W. Leap.)

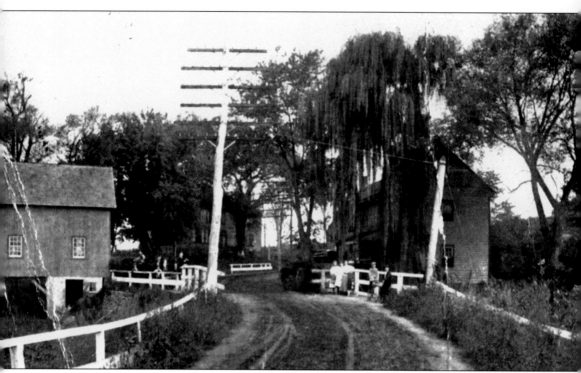

**"S" CURVE WEST, CHEWS LANDING, 1907.** This photograph was taken from a position on the bridge over Big Timber Creek in Chews Landing looking toward Glendora. The steep slope on the Black Horse Pike is apparent here, as is the danger facing the driver of a team of horses or a balky early automobile. Over time, this stretch of the pike became ominously known as the "Death Curve." (Courtesy of William W. Leap.)

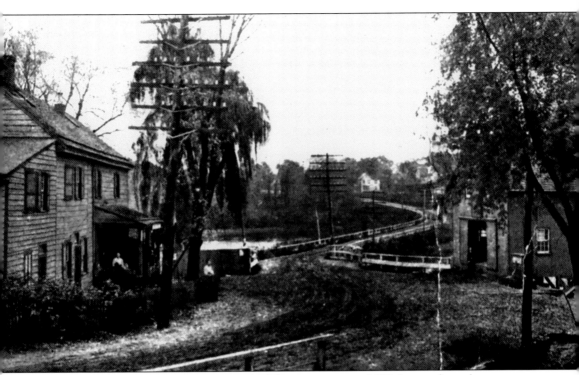

**"S" Curve East, Chews Landing, 1907.** This view is turned 180 degrees from the one seen on the previous page. Looking from Glendora into the village of Chews Landing, the Brewer residence is seen at left. In addition to their business transporting local commodities (marl, coal, and supplies), the Brewer Shipyard was also located here. This treacherous stretch of the pike would not be graded and straightened until 1929, when the new Black Horse Pike was constructed bypassing the area pictured here. (Courtesy of William W. Leap.)

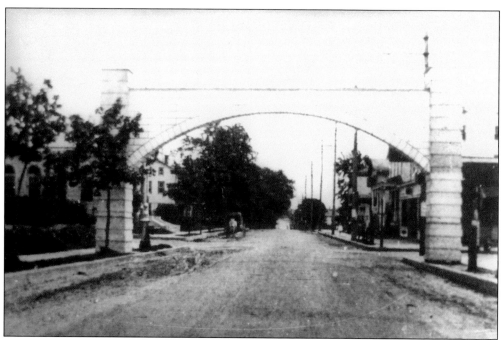

WORLD WAR I VICTORY ARCH, BLACKWOOD, C. 1919. The intersection of the Black Horse Pike and Church Street grew as Blackwood's town center, so it was natural that the victory arch marking the end of World War I was constructed there. (Courtesy of the Gloucester Township Historical Society.)

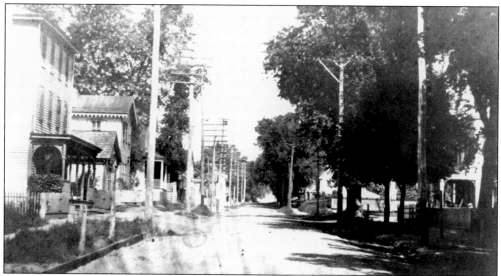

MAIN STREET, BLACKWOOD, C. 1900. The Black Horse Pike was known by many names throughout its history, including Main Street through Blackwood. This image shows the progression of residential development along the tree-lined pike. (Courtesy of Jack Simpson.)

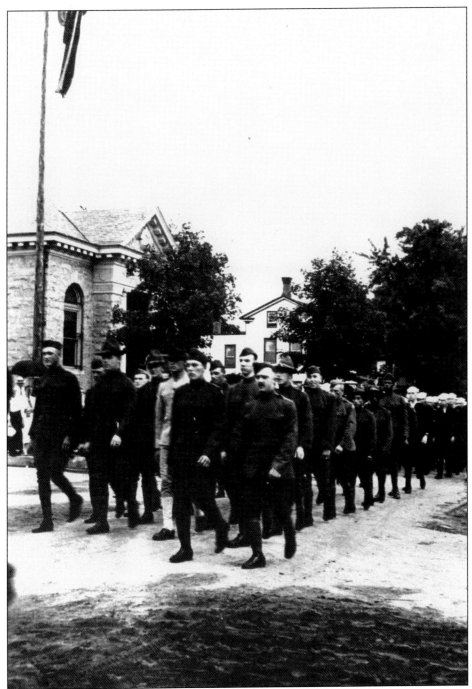

**WORLD WAR I HOMECOMING PARADE, 1919.** Although the Black Horse Pike had not yet been paved, improvements had been made to allow for the relatively smooth traffic of the day: horse-drawn wagons and the earliest automobiles. The pike is also obviously the main street through Blackwood as indicated by the homecoming parade for World War I veterans. Arthur Beetle (front right) leads the regiment of veteran soldiers and sailors north at Church Street. The stone building at the left is the First National Bank of Blackwood. (Courtesy of Jack Simpson.)

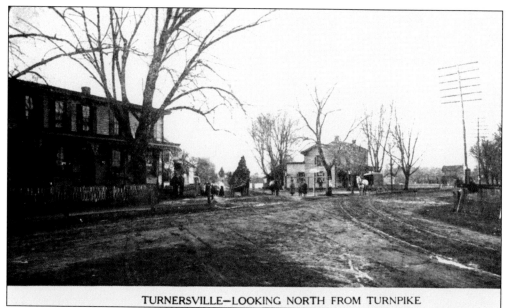

TURNERSVILLE—LOOKING NORTH FROM TURNPIKE

BLACK HORSE PIKE, TURNERSVILLE, C. 1900. The intersection of the pike and Sicklerville Road in Turnersville remains a major intersection today near the Atlantic City Expressway. The large building at the left still stands and was once Tom Jackson's grocery and meat store. Watson's Quality Food Products is now located on the site of the house (center). (Courtesy of Jack Simpson.)

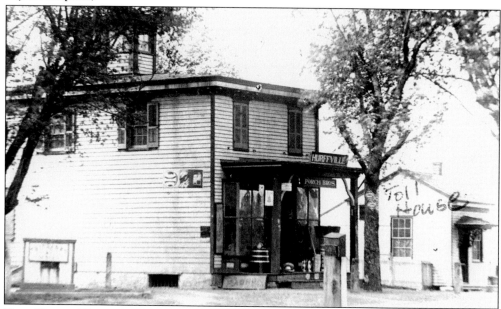

TOLL HOUSE, HURFFVILLE, C. 1900. Many major roadways through the area were toll roads for a time. Toll keepers, employed by the turnpike companies, lived in a small house similar to this one next to the Porch Brothers store in Hurffville, just south of Turnersville. Tolls, assigned by a sometimes complex set of guidelines, were collected to improve and maintain the roadways. The Black Horse Pike was a toll road from 1855 until 1903, when Camden County purchased the road and lifted the tolls. (Courtesy of Jack Simpson)

**TRAIN STATION, WILLIAMSTOWN, 1953.** Despite the increasing popularity of Atlantic City as a vacation destination, neither the Black Horse Pike nor the Camden, Gloucester and Mount Ephraim Railway were extended to permit travel beyond Williamstown and Grenloch, respectively. (Courtesy of R. L. Long)

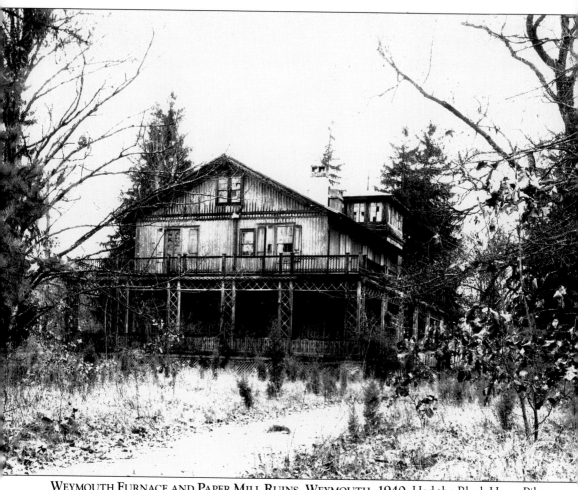

**Weymouth Furnace and Paper Mill Ruins, Weymouth, 1940.** Had the Black Horse Pike and the Grenloch Branch of the Camden, Gloucester and Mount Ephraim Railway (also known as the Peanut Line) been extended, travelers would have continued through to Weymouth. The Weymouth Furnace was built in about 1754 and first operated by Joseph Ball. Five partners purchased the land just north of the pike in 1800. The State of New Jersey granted the partners permission to dam the Great Egg Harbor River in order to power their forge. Iron production began in 1802 with the manufacture of cast-iron water pipe, pots, stoves, and nails. Bombs and shot manufactured in Weymouth were supplied to the U.S. government for use during the War of 1812. (Courtesy of R. L. Long.)

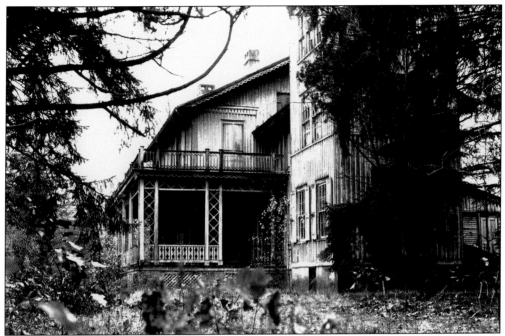

**OWNER'S MANSION, WEYMOUTH, 1940.** The iron forge remained in production for about 60 years, smelting bog iron in charcoal-powered furnaces. At its productive peak, the forge employed nearly 900 men, and a village evolved around the works including a gristmill, a Methodist church, a store, blacksmith shop, a wheelwright, and the impressive owner's mansion pictured here. (Courtesy of R. L. Long.)

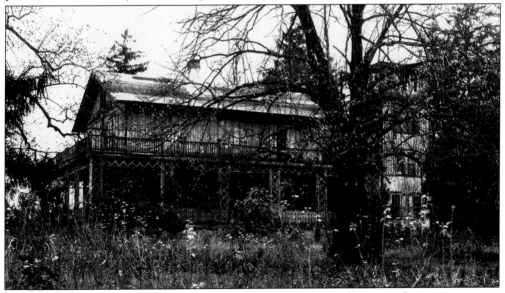

**WATER TOWER, WEYMOUTH, 1950.** The forge was forced out of business due to competition from forges in Pennsylvania which were powered by cheaper anthracite coal. The Weymouth Forge is reported to have burned in 1862. Note the three-story structure to the right of the mansion. The third floor contained a wooden water tank. These ruins burned sometime after 1953. (Courtesy of R. L. Long.)

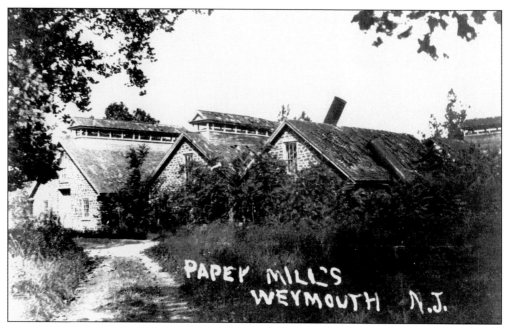

ATLANTIC PAPER MILLS, WEYMOUTH, C. 1900. After the iron works was destroyed by fire, two paper mills were built on the site: Atlantic Paper Mills, pictured here, and Weymouth Paper Mills, a wooden structure. The mills manufactured paper from fibrous materials including rags and manila rope. Mass production of wood pulp–based paper put the Weymouth mills out of business in 1897. (Courtesy of R. L. Long.)

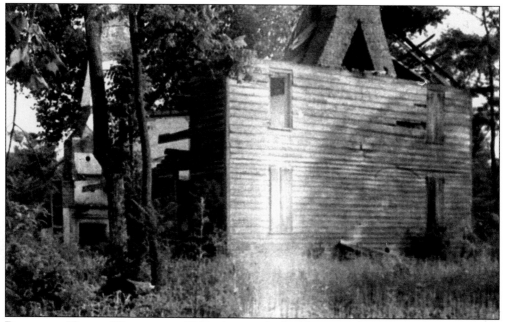

BOARDING HOUSE, WEYMOUTH, 1948. Among the buildings on the Weymouth Furnace site were a number of boarding houses for forge workers. After the paper mills went out of business, the land was sold to satisfy debts, and the property soon fell into disrepair. The remains of the boarding houses, such as this one, were razed in 1949. (Courtesy of R. L. Long.)

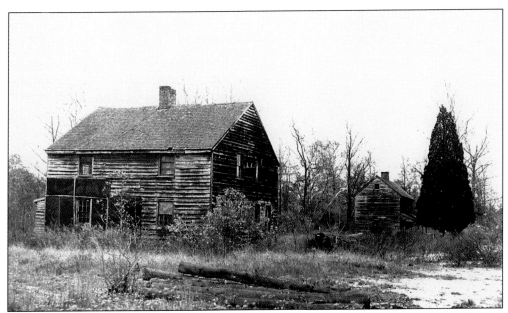

RESIDENCE, WEYMOUTH, 1948. This private residence was built on the Weymouth Furnace land in addition to boarding houses for forge and paper mill workers. The Great Egg Harbor River dam deteriorated along with the wooden buildings. The dam failed in 1916, draining the mill pond. (Courtesy of R. L. Long.)

WORKER HOUSING, WEYMOUTH, 1950. All of the buildings on the Weymouth Furnace site have fallen into ruin. The only remains are the stone foundations. They are preserved as part of the Atlantic County Park System. (Courtesy of R. L. Long.)

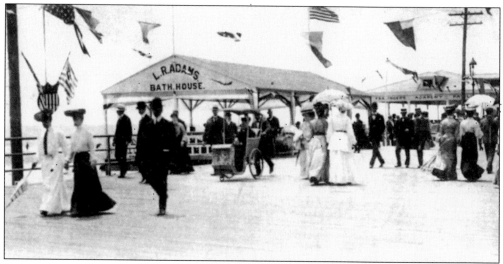

BOARDWALK, ATLANTIC CITY, C. 1900. Had the Black Horse Pike continued through Weymouth, travelers would have reached Atlantic City and the ocean shore in just a few miles. While improvements to the pike were slow to be made, Atlantic City officials responded quickly to demand. Temporary boardwalks had been so successful in reducing the amount of sand tracked into hotel lobbies and onto trains, that permanent structures were constructed. Services, including lifeguards on duty, were instituted. Amusements, entertainment, and food attracted even more visitors and shifted the image of Atlantic City from health resort to playground. (Author's collection.)

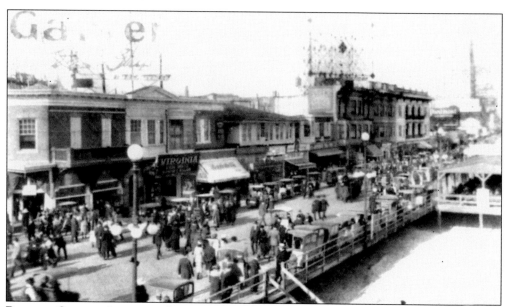

ROLLING CHAIRS, ATLANTIC CITY, C. 1910. The success of the boardwalk gave rise to another nifty invention—the rolling chair. Seating two foot-weary vacationers, the canopied rolling chairs are pushed from behind. The bumper-to-bumper line of chairs pictured here is a harbinger of the string of automobiles that would clog the Black Horse Pike a generation later as the pike became a through road between Camden and Atlantic City. (Author's collection.)

## Two

# The Peanut Line

After the Revolutionary War, a series of forces began to reshape transportation in the area around the Big Timber Creek communities.

The lumbermen cleared forests farther and farther from the banks of Big Timber Creek. More settlers arrived in the area and plotted out their farms on the newly cleared land. Routes connecting the far-flung farms were developed, and thus, an expanding network of roads evolved shifting transportation away from Big Timber Creek.

Soil, eroded from the cleared farmland, began to clog the creek, further reducing the utility of the creek for shipping. Despite their poor condition, by the late 1800s, roads were now the preferred transportation routes of manufacturers, lumbermen, and farmers. Traffic along the Black Horse Pike continued to increase.

The boggy, hilly pike did not meet the needs of one manufacturer in Grenloch.

Frank Bateman, who with his brother, Edward, manufactured agricultural equipment, needed a better and more profitable way to move merchandise from their inland factory to the river port at Camden and points beyond.

The only solution to the shipping problem was to build a train line to his factory; a line established in 1891 that would become known as the Peanut Line.

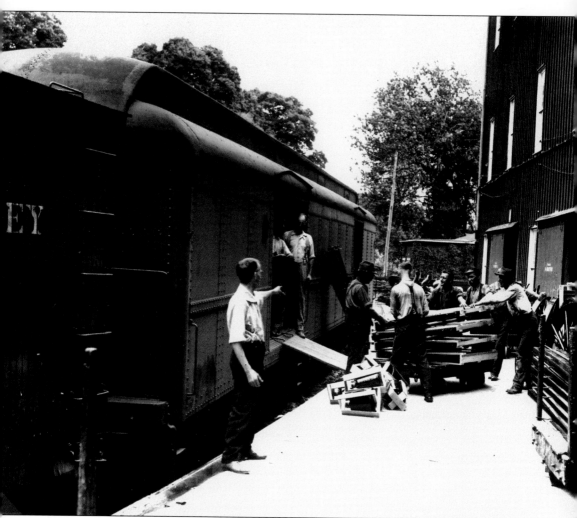

**BATEMAN MANUFACTURING COMPANY LOADING DOCK, GRENLOCH, C. 1920.** The Grenloch Branch of the Camden, Gloucester and Mount Ephraim Railway, also known as the Peanut Line, was opened in 1891 after Frank Bateman appealed to the Philadelphia and Reading Railroad Company to extend the railway from Mount Ephraim as his need for shipping his manufactured goods outgrew the modes of transportation available to him. The railroad executives agreed on the condition that Bateman would secure the necessary rights of way. (Courtesy of Jack Simpson.)

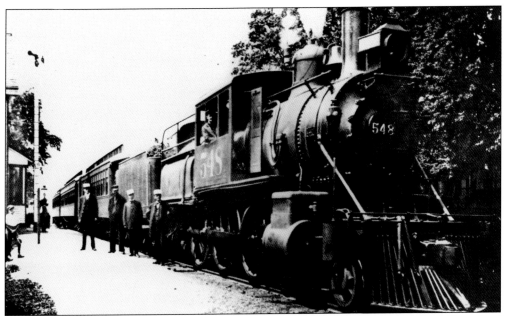

THE PEANUT LINE, GRENLOCH, C. 1910. The engineer and crew of the Grenloch Branch of the Camden, Gloucester and Mount Ephraim Railway pose along the tracks. The Peanut Line was most likely named due to its short route, about eight miles between Mount Ephraim and Grenloch. (Courtesy of Jack Simpson.)

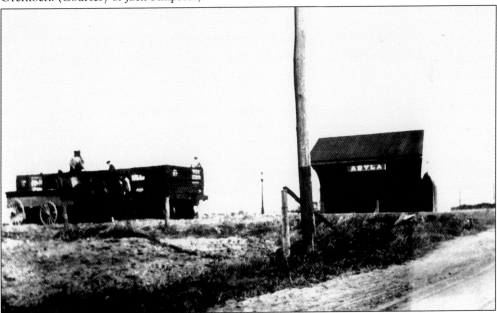

ASYLA STATION, GRENLOCH, 1932. Bateman gained right of way for the line through personal appeals to property owners along the route just west of the pike. Bateman was also required to change the name of the terminus. He chose the name "Grenloch" and soon thereafter the line began transporting not only Bateman products, but also carloads of passengers. One minute outside of Grenloch, the train stopped at Asyla Road, now known as Davistown Road at Lakeland. (Photograph by Francis Palmer, courtesy of R. L. Long.)

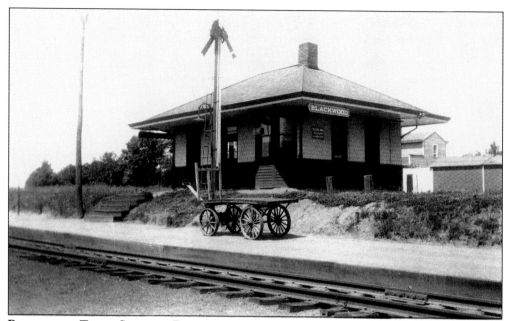

BLACKWOOD TRAIN STATION, BLACKWOOD, 1932. In two minutes, the train pulled into the station at Church Street overlooking Blackwood Lake. A red caboose now sits on the site and is preserved by the Blackwood Lake Advisory Committee. The tracks have been converted into a bike path. The train station building has been moved to Washington Township and is preserved there. (Photograph by Francis Palmer, courtesy of R. L. Long.)

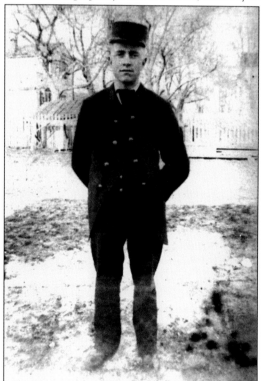

RAILROAD AGENT KLEIN, BLACKWOOD, 1892. William Klein is known to be the first railroad agent employed at the Blackwood train station. Agents not only sold tickets to passengers, but coordinated with railroad crews and managed the paperwork associated with moving passengers and freight. (Courtesy of the Gloucester Township Historical Society.)

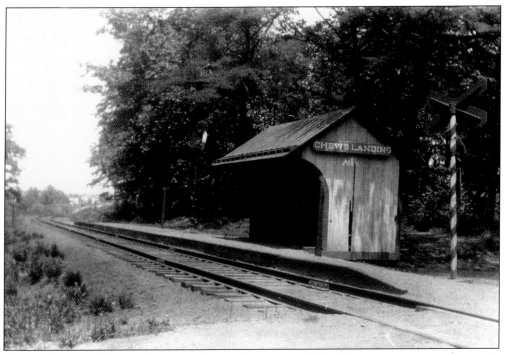

**CHEWS LANDING TRAIN STATION, CHEWS LANDING, 1932.** After six minutes and stops in Blenheim and Hilltop, passengers arrived in Chews Landing. In 1902, seven trains ran Monday through Saturday between Mount Ephraim and Grenloch. An eighth train was added on Wednesday and Saturday. Only three trains were scheduled on Sunday. (Photograph by Francis Palmer, courtesy of R. L. Long.)

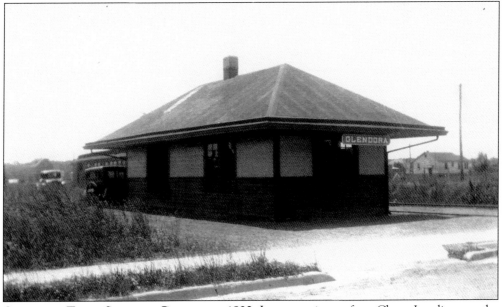

**GLENDORA TRAIN STATION, GLENDORA, 1932.** Just two minutes from Chews Landing was the town of Glendora. The station was located one block west of the Black Horse Pike on the aptly named Station Avenue. (Photograph by Francis Palmer, courtesy of R. L. Long.)

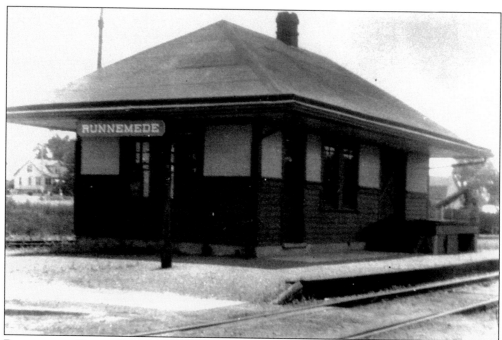

RUNNEMEDE TRAIN STATION, RUNNEMEDE, 1932. After a two-minute ride from Glendora, passengers arrived in Runnemede. The Peanut Line provided convenience to both residents and visitors as the center of town and Runnemede Lake were each just a short walk from the train station. This section of the tracks has also been converted into a bike path. (Photograph by Francis Palmer, courtesy of R. L. Long.)

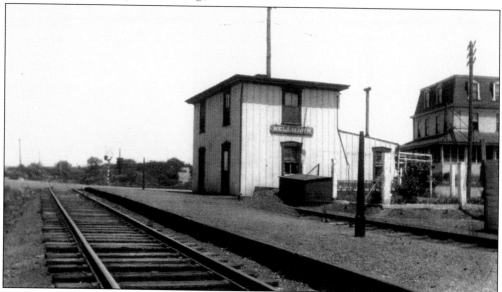

BELLMAWR TRAIN STATION, BELLMAWR, 1932. Bellmawr was a quick three minutes from Runnemede. The short section of the line between Bellmawr and Mount Ephraim is still in use today. Weyerhaeuser (manufacturer of building, paper, and packaging materials) and John-Jeffrey Corporation (warehousing and transportation) make three to four shipments per week. (Photograph by Francis Palmer, courtesy of R. L. Long.)

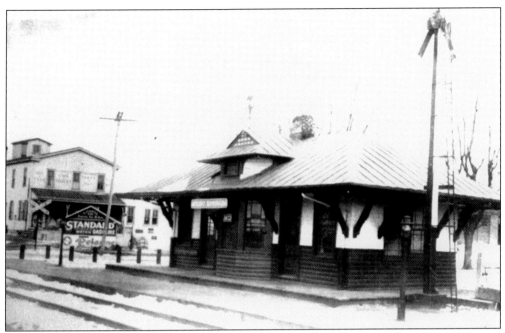

TRAIN STATION, MOUNT EPHRAIM, C. 1920. The Peanut Line terminated in Mount Ephraim, four minutes from Bellmawr. Passenger service ceased on the Grenloch Branch of the Camden, Gloucester and Mount Ephraim Railway in 1941. (Courtesy of William W. Leap.)

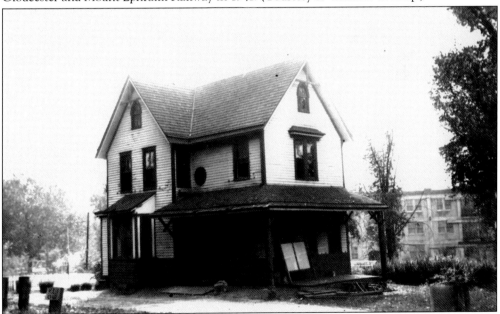

TRAIN STATION, GRENLOCH, C. 1950. After passenger service ceased along the Peanut Line, stations fell into disrepair. The Grenloch station has been preserved and is now a private residence. The building in the background at right is part of the A. L. Hyde Company complex, formerly the Bateman Manufacturing Company. The A. L. Hyde Company was one of the world's first processors of plastics. The company specializes in high-performance materials including Kevlar-reinforced nylon. (Courtesy of Jack Simpson.)

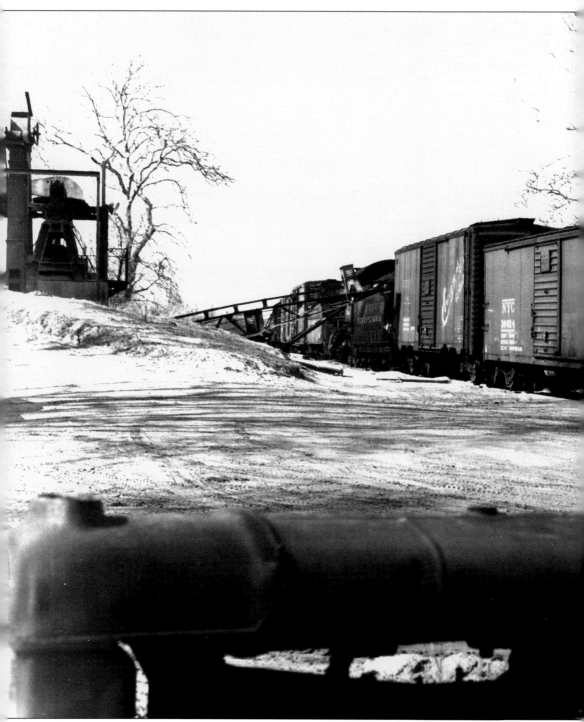

**SHIPPING SAND, GRENLOCH, 1954.** Throne's Trucking Company's enterprise kept the railroad between Mount Ephraim and Grenloch an active freight line for another 20 years. In this image, sand is pumped over the conveyor belt and into boxcars for shipment to industrial customers. In the foreground is a Fordson tractor. Manufactured by the Henry Ford and Son Company in

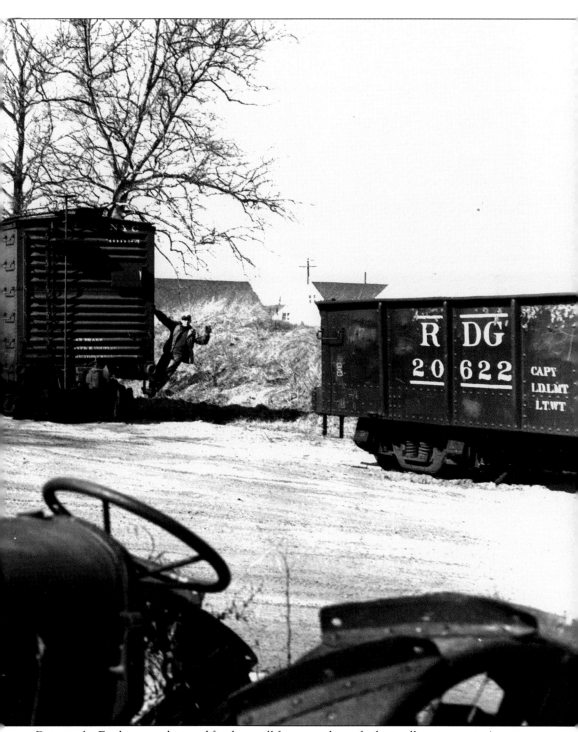

Detroit, the Fordson was designed for the small farmer and was the best-selling tractor in America for every one of its production years, 1918 to 1928. The frameless vehicle had its quirks, one of which included flipping over while riding up the slightest incline. (Courtesy of Jack Simpson.)

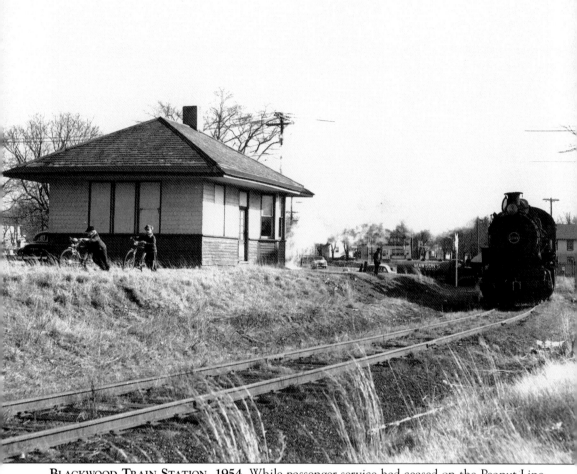

**BLACKWOOD TRAIN STATION, 1954.** While passenger service had ceased on the Peanut Line in 1941, freight was moved along the length of the line until 1973, when the section between Glendora and Grenloch was abandoned for lack of business. The segment between Glendora and Bellmawr was abandoned in 1981 when Conrail removed the tracks in order to recover some costs. The last fraction of the original line is still in operation. Several trains a week run between Bellmawr and Mount Ephraim and continue to Gloucester City. (Photograph by R. L. Long, courtesy of Jack Simpson.)

# *Three*

# THE BLACK HORSE PIKE

While trains are wonderfully efficient and reliable, their routes and schedules are unresponsive to change. Routes can become obsolete as centers of manufacture and commerce shift. Likewise people would rather choose their own departure time and route of travel. The highly regulated railroad system simply could not compete with the flexibility afforded by cars and trucks.

As the internal-combustion engine was perfected in the early 20th century, dozens of automobile makes and models rolled out of workshops and factories and onto the dusty, rough-cut roads. The love affair with automobiles blossomed so quickly that by 1924, one in seven Americans owned a car.

While small communities along the pike thrived, car-owning residents were no longer reliant upon them for every need. An automobile provided unprecedented flexibility as to where one lived, shopped, and played.

Born was the commute to work and the day trip for recreation, and as with every other stage of commercial development, entrepreneurs were ready to meet the needs of the get-up-and-go population. Gas stations and quick-stop eateries popped up on every roadside.

But not all vehicles were cars. Trucks harnessed the horsepower to move heavy freight and the speed and flexibility to ship perishables such as tomatoes and other produce direct from the farm to market. Buses not only moved people around town, but soon charter buses moved groups of people who had neither the means nor the inclination to travel by automobile.

With so many vehicles motoring about, the demand for road improvements was strong. Roads were graded and paved. Lights were installed to aid nighttime drivers. Lastly safety measures were developed and the officers to enforce traffic rules employed.

The modern Black Horse Pike had taken shape.

**JACKRABBIT AUTOMOBILE, BLACKWOOD, C. 1910.** Americans have loved cars since the industry's infancy. Sleek styling and powerful engines might define the driver, but most people will drive any bucket of bolts as long as their wanderlust can be fulfilled. The Jackrabbit line of automobiles was manufactured by Apperson Brothers Automobile Company of Kokomo, Indiana. Their first cars, touring sedans, rolled off the production line in 1904. Brothers Elmer and Edgar Apperson were racing fanatics and entered their automobiles in all the major races of their day, including the 1911 Indianapolis 500. The Appersons' passion for racing is reflected in their Jackrabbit Speedster, which was introduced in 1907 and boasted a 60-horsepower engine. (Courtesy of the Gloucester Township Historical Society.)

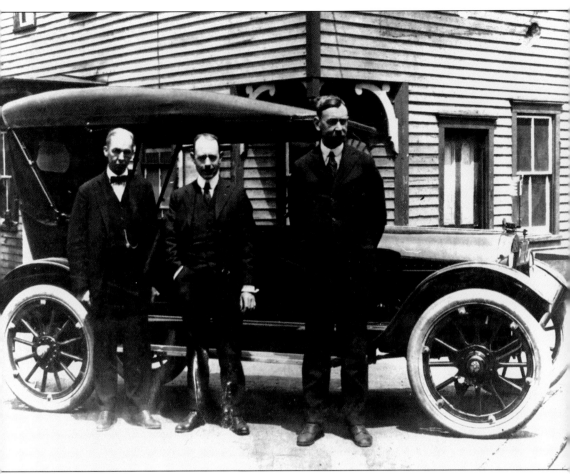

**THE FRONTMOBILE TOURING SEDAN, GRENLOCH, C. 1918.** Not only were drivers passionate about their cars, but so was anyone with some manufacturing know-how. Dozens tried their hand at automobile production including the Bateman Manufacturing Company of Grenloch, who produced only one Frontmobile Touring Sedan. The car was designed by Charles Blomstrom, who had a long career manufacturing marine engines and other automobiles in Detroit. The Frontmobile boasted a low center of gravity, and its front-wheel drive design permitted a firm grip on the road surface, reducing skidding in curves or on slippery roads. The car is currently housed in the National Automobile Museum in Reno. (Photograph by M. A. S. Stanley, courtesy of Jack Simpson.)

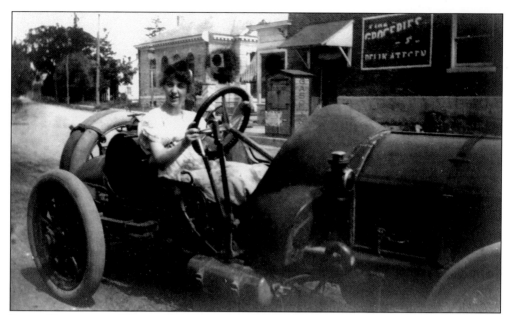

**LACEY BEHIND THE WHEEL, BLACKWOOD, C. 1920.** Automobiles were novelties in the 1920s and not the necessities we know today, but Lacey, ready for her test drive on West Church Street in Blackwood, has a number of levers and probably foot pedals to operate. Note two spare tires are strapped to the rear of the car. (Courtesy of the Gloucester Township Historical Society.)

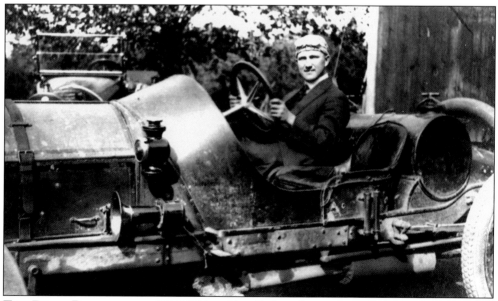

**TEST DRIVE, BLACKWOOD, C. 1920.** This unidentified gentleman is seated in the same automobile pictured at the top of the page. Wearing cap and goggles, he appears to be well-prepared to travel the unpaved roads in the region. Note the leather strap that secures the hood of the vehicle and that the driver sits on the right. (Courtesy of Gloucester Township Historical Society.)

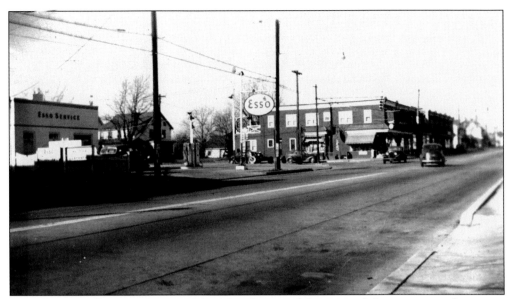

Esso Station, Blackwood, c. 1940. Manufacture of the automobile gave rise to the service station industry. Gas, oil, tires, and repairs were the mainstays of early service stations. Not long afterward, entrepreneurs began offering food and beverages to weary travelers, too. Pictured here is the Esso station at the intersection of the Black Horse Pike and Church Street. Note the pike is paved, lighted, and even sports a traffic signal at this busy intersection. The brick building (center) is still standing today with storefronts on the first floor and apartments above. (Courtesy of Jack Simpson.)

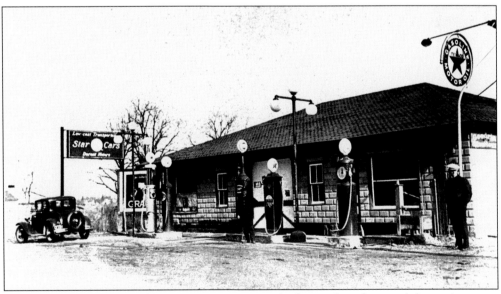

John Murphy's Garage, Turnersville, c. 1920. As the number of automobiles on American roads increased, so did the number of service stations. John Murphy not only sold Texaco gasoline at 16¢ per gallon, but it appears he also sold Star Cars, "low-cost transportation," manufactured by Durant Motors. (Courtesy of Jack Simpson.)

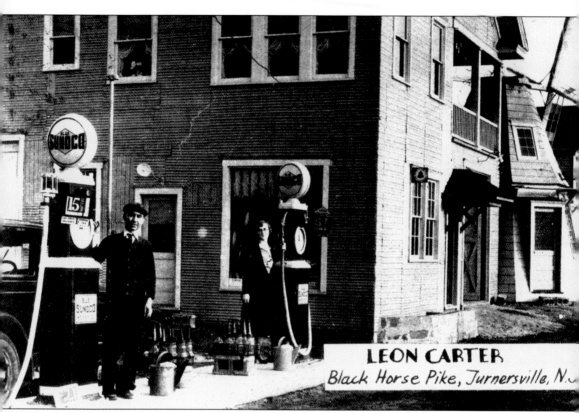

**LEON CARTER**
*Black Horse Pike, Turnersville, N.J.*

CARTER'S SERVICE STATION, TURNERSVILLE, C. 1920. Attentive owners, gasoline, a telephone—travelers have required these essentials since first taking to the roads. Leon Carter and wife attend to their 15¢-per-gallon Sunoco pumps on the Black Horse Pike in Turnersville. Note the windmill-shaped building (right). (Courtesy of Jack Simpson.)

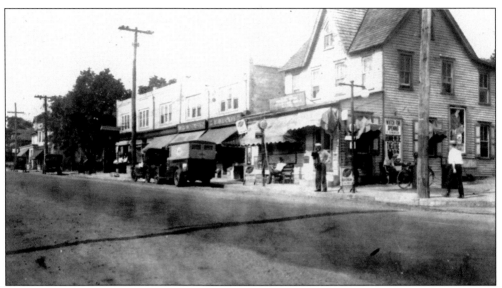

**BUSINESS CENTER, RUNNEMEDE, C. 1928.** Commercial centers were very well defined along the Black Horse Pike by the 1920s and were convenient to customers with and without automobiles. Business in Runnemede is anchored by Hunter's general store at the intersection of the pike and Clements Bridge Road. The pike is paved, telephone poles have replaced telegraph poles, and the Runnemede Theatre will be opening soon. Hunter's general store even has a gas pump. (Courtesy William W. Leap.)

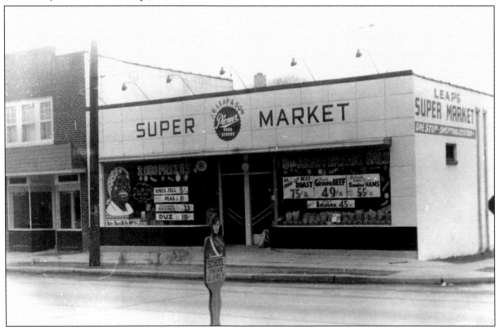

**J. R. LEAP & SON SUPER MARKET, RUNNEMEDE, 1950.** Jack Leap opened his Super Market on the southwest corner of the Black Horse Pike and Second Avenue in Runnemede, next door to his original market (left). The Super Market, opened in 1947, was the first self-service grocery on the pike. The store was a model for modern grocery stores in that it featured continuous fluorescent lighting and freezers with sliding glass doors. (Courtesy of William W. Leap.)

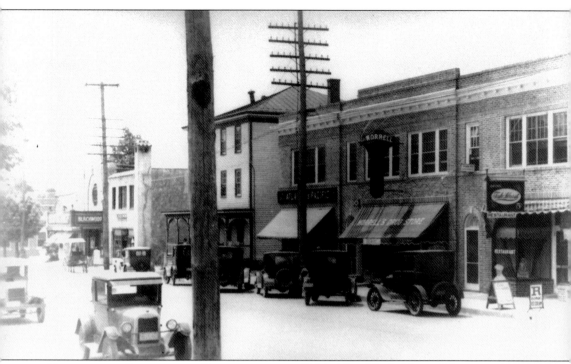

DOWNTOWN BLACKWOOD, BLACKWOOD, C. 1924. The Black Horse Pike near Church Street has become a hub of activity. Included in this block of commercial establishments are the new Blackwood Theater, an A&P market, Worrell's drug store, and an Italian restaurant. Street parking appears to be a skill not yet perfected. (Courtesy of the Gloucester Township Historical Society.)

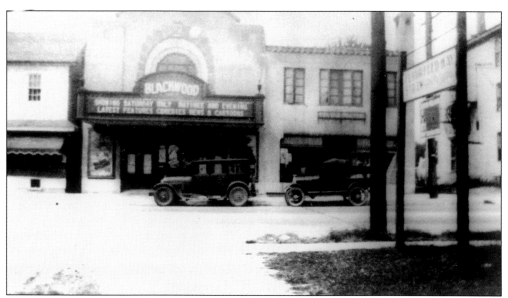

**BLACKWOOD THEATER, BLACKWOOD, C. 1925.** Established in 1921, the Blackwood Theater on the Black Horse Pike seated 488 and featured Saturday matinees and the latest features, comedies, news, and cartoons. Co-existing with the modern motion picture house is the farm supply store. The sign at the far right advertises flour, feed, hay, and straw. (Courtesy of the Gloucester Township Historical Society.)

**BLENHEIM SILK HOSIERY MILL, BLACKWOOD, C. 1920.** Blackwood was home to several mills just before the Great Depression, including two hosiery mills. The stock market crash of 1929, combined with increasing pressure by workers for decent wages and working conditions, applied pressure to manufacturers. The Blenheim mill closed for a period of five months when workers walked off the job in protest over wages. When the workers returned, their pay had not increased, but management had capitulated to negotiate with the newly formed union per the Wagner Act of 1935. (Courtesy of the Gloucester Township Historical Society.)

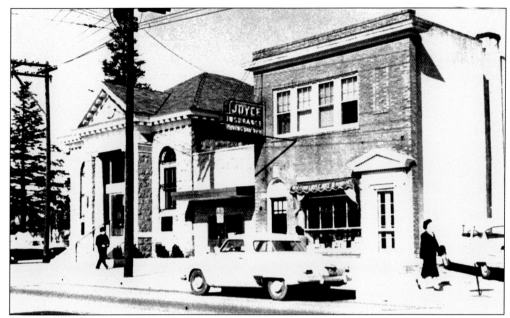

DOWNTOWN BLACKWOOD, C. 1955. A community's needs are reflected in the face of its businesses. Changes are evident in this view of the Black Horse Pike near Church Street looking north. Next to the bank is an insurance company. The bank building on the corner remains a landmark although today it is a rehabilitation center and Louis C. Joyce Insurance Company is now a dentist's office. (Courtesy of Jack Simpson.)

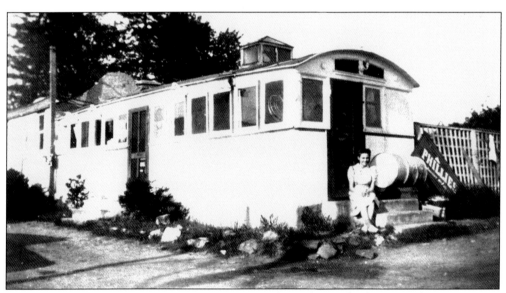

RUNNEMEDE DINER, RUNNEMEDE, C. 1940. Road travel gave birth to another segment of industry, the roadside diner. When Americans took to the roads in their cars, they not only sought new destinations, but also good food along the way. Popular stops were accessible, fast, friendly, and of course, served delicious food. Dot Philbin sits on the steps of the tiny Runnemede Diner located on the southeast corner of the pike and Clements Bridge Road. Today the Phily Diner is a popular eatery at the same location. (Courtesy William W. Leap.)

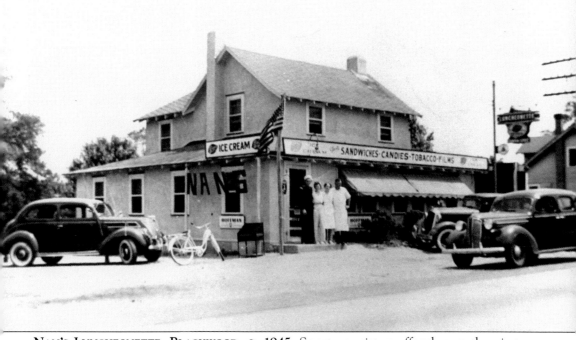

**Nan's Luncheonette, Blackwood, c. 1945.** Smart proprietors offered more than just a good, quick meal. Road travelers love one-stop shopping, and Nan was smart to offer film and other necessities for vacationers on their way to the Jersey Shore. (Courtesy of Jack Simpson.)

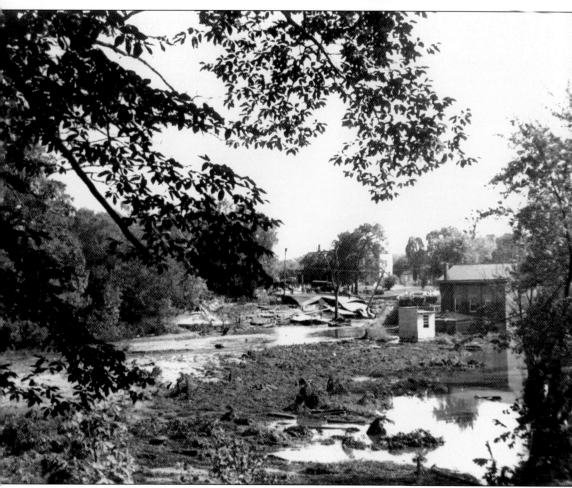

**BLACKWOOD LAKE FLOOD DAMAGE, BLACKWOOD, 1936.** The first of two Labor Day weekend floods, four years apart, ravaged the idyllic setting at Blackwood Lake. In this view from Woodbury-Clementon Road, hunks of the roadway are seen broken and pushed by the floodwaters into a crazy stack (center). The damage at both Blackwood Lake and Grenloch Lake was repaired and summer activities resumed the following year. (Courtesy of the Gloucester Township Historical Society.)

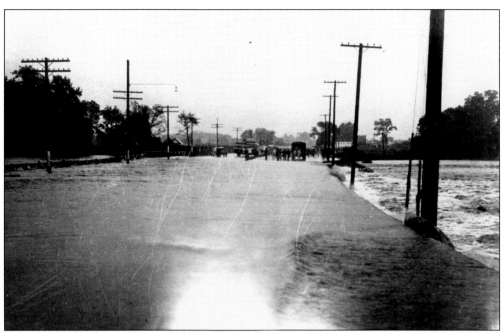

FLOOD BLOCKING PIKE TRAFFIC, BLACKWOOD, 1940. On September 6, 1940, rain again fell in such quantity that Big Timber Creek, Blackwood Lake, and Grenloch Lake overflowed their banks. Floodwaters swamped the Black Horse Pike, stopping all traffic including buses and trucks. Drivers gather at the edge of the torrent and wait for safe passage. (Courtesy of Jack Simpson.)

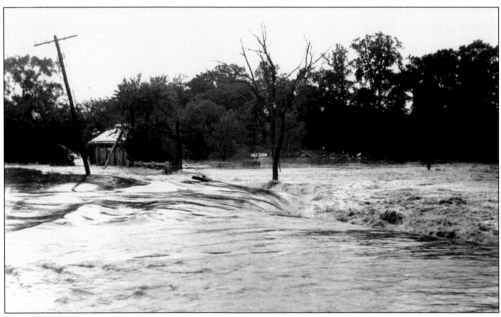

RAGING FLOODWATERS, BLACKWOOD LAKE, 1940. Both the Grenloch Lake and Blackwood Lake dams failed, transforming tranquil Blackwood Lake into a raging river. The flood swept away the dams, roadways, trees, and buildings and washed away any plans for traditional Labor Day weekend boating and swimming activities. (Courtesy of Jack Simpson.)

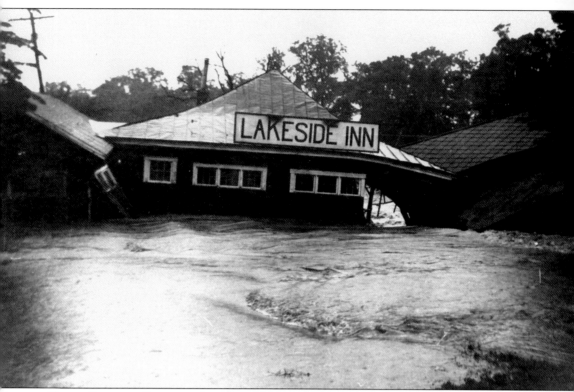

**Flood-Ravaged Lakeside Inn, Blackwood, 1940.** The force of the floodwaters is evident in the destruction seen here to the Lakeside Inn. Until its destruction, guests at the inn enjoyed lakeside music, dances, regattas, and other activities. The flood did not halt summer fun for long. Reconstruction around the lake began quickly, and it remained a recreation destination until 1960. (Courtesy of Jack Simpson.)

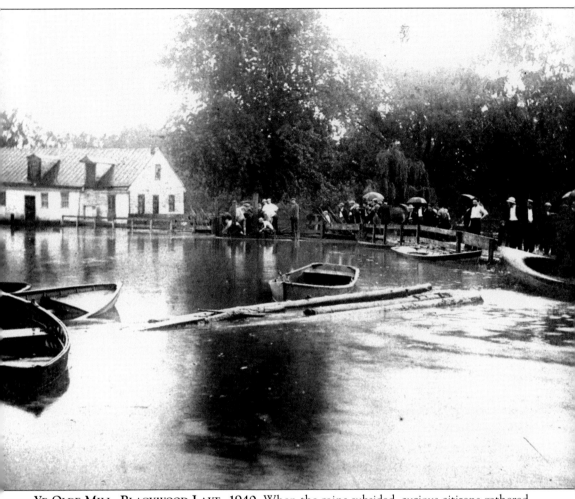

**YE OLDE MILL, BLACKWOOD LAKE, 1940.** When the rains subsided, curious citizens gathered to view the swollen Blackwood Lake and destruction to docks and Ye Olde Mill. The mill, built in 1859 and pictured on page 16, was damaged but not destroyed. (Courtesy of Jack Simpson.)

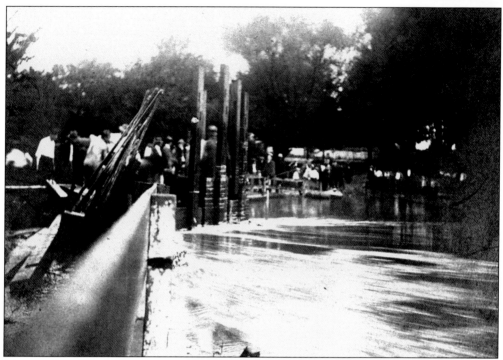

**WASHED OUT DAM, BLACKWOOD, 1940.** This view from near Ye Olde Mill on Blackwood Lake shows the ravaged dam. The 1940 flood was the second Labor Day weekend flood in four years. (Courtesy of Jack Simpson.)

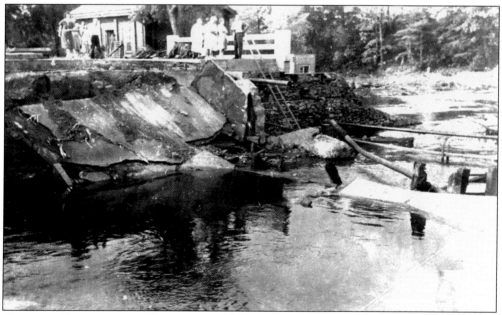

**RECEDING FLOODWATERS, BLACKWOOD, 1940.** As the September 6, 1940, floodwaters began to recede, the extent of the damage became clear. The roadway's structure has been washed away, and its infrastructure splintered. The floods were not the first setbacks for Blackwood Lake recreation. (Courtesy of Jack Simpson.)

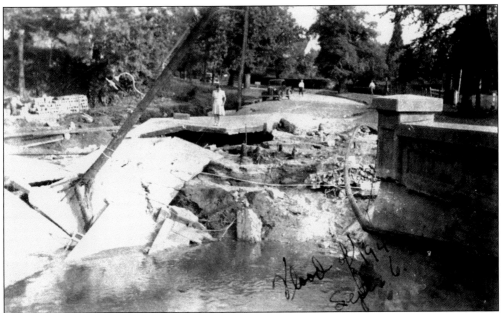

FLOOD-DAMAGED WOODBURY
ROAD (ABOVE) AND WOODBURY
ROAD BRIDGE (RIGHT),
BLACKWOOD, 1940. Blackwood
Lake was closed to swimmers
in 1934 due to issues with
the nearby Lakeland hospital
facility's sewage system. Local
residents urged their councilmen
to solve the problem in order to
save Blackwood Lake. As the
hospital's sewage system was
explored, it was discovered that
private privies and cesspools
were also emptying into the
lake. A new sewer system, an
ordinance prohibiting digging
new cesspools, and the operation
of a sewage treatment plant at
Lakeland controlled the sewage
problem. In 1937, Blackwood
Lake was declared safe for
swimming again. The flood
damage, surveyed by onlookers in
these images, forced yet another
temporary closing of the lake.
(Courtesy of Jack Simpson.)

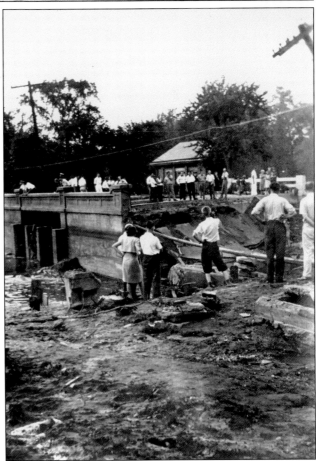

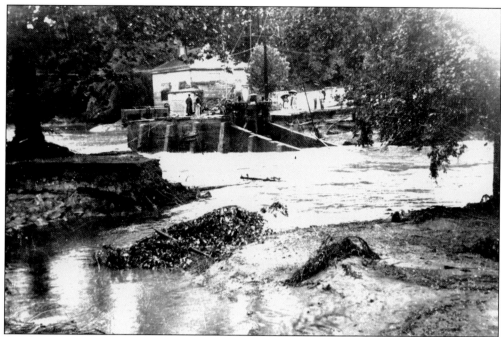

GRENLOCH LAKE FLOOD, GRENLOCH, 1940. Flood damage was significant to the Grenloch Lake dam, too, as is evident in this image. Compare the destruction to the idyllic setting in the image on page 17. (Courtesy of Jack Simpson.)

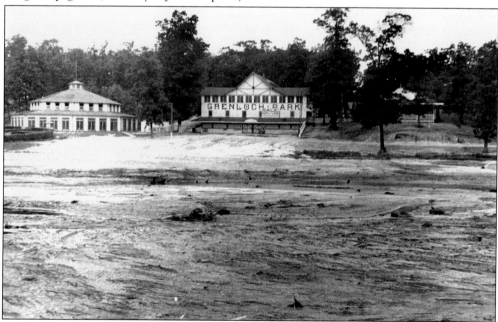

GRENLOCH PARK, GRENLOCH, 1940. Just days before this photograph was taken, the shores of Grenloch Lake had been lively with fun-seekers enjoying the last days of summer. While swimming, canoeing, and sunning were popular activities, Grenloch Park also boasted a carousel, which was housed in the large round building (left). Lucky riders might catch the brass ring and earn a free ride. (Courtesy of Jack Simpson.)

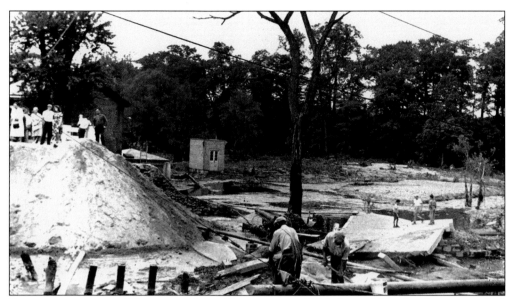

RECONSTRUCTION OF WOODBURY ROAD, BLACKWOOD, 1940. As quickly as floodwaters receded, reconstruction began. Evident is the magnitude of the destructive force of rushing water. Note the chunk of concrete roadway where three children are playing (right). Portions of the berm have been washed away, along with trees and small buildings. (Courtesy of Jack Simpson.)

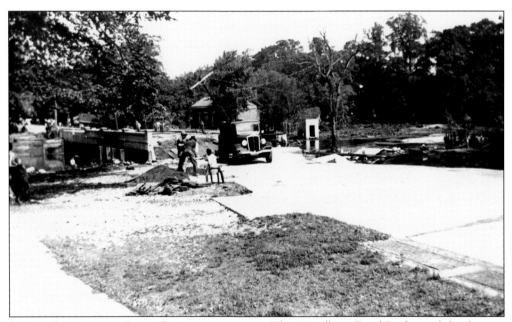

SAVING BLACKWOOD LAKE, BLACKWOOD, 1940. The Woodbury Road Bridge and the dams at Blackwood Lake and Grenloch Lake were rebuilt yet again, but the effort was futile in the long run. While summer activities resumed, the lakes were again contaminated. An investigation discovered that runoff from many areas along Big Timber Creek was to blame. Blackwood Lake was condemned again in 1960. (Courtesy of Jack Simpson.)

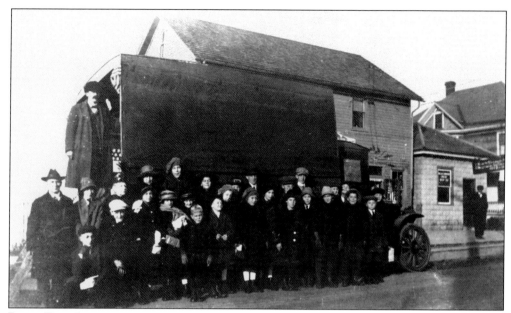

ROAD TRIP, BLACKWOOD, C. 1910. Cars were not the only product of the internal-combustion engine. Trucks of course were designed to move cargo, but some visionaries also designed vehicles to move large numbers of people. The first buses were often crudely converted trucks, as the vehicle pictured here. It certainly served to move these children to their destination but offered little in the way of comfort. (Courtesy of Jack Simpson.)

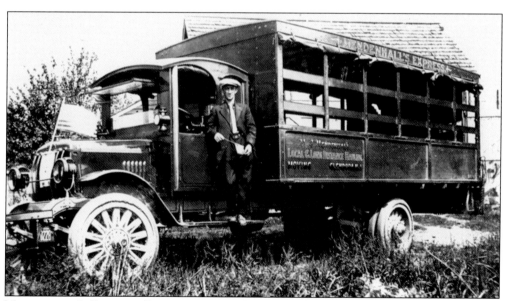

MENDENHALL'S EXPRESS, GLENDORA, 1919. Harry Mendenhall was an entrepreneur who not only performed local and long distance hauling in his truck, but he also equipped the vehicle with benches and transported men to the Philadelphia Naval Shipyard. This was the first step in a successful career in bus operation. (Courtesy of William W. Leap.)

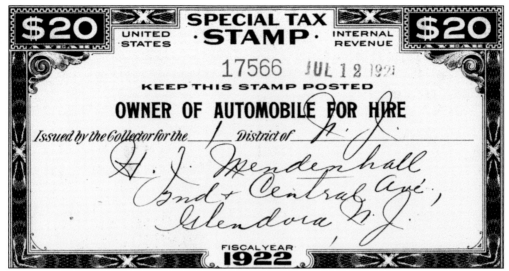

MENDENHALL'S BUS OPERATION LICENSE, 1922. Mendenhall's ridership soon outgrew the capacity of his makeshift bus. Rather than continue in commuter bus service, he turned his sights to the charter industry. He applied for and received, on July 12, 1921, his bus operator's license. Mendenhall's service operated 53 buses by the time he retired. (Courtesy of William W. Leap.)

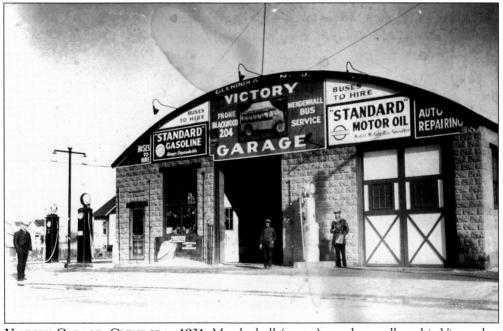

VICTORY GARAGE, GLENDORA, 1931. Mendenhall (center) stands proudly at his Victory bus garage on the southeast corner of the Black Horse Pike and Tenth Avenue in Glendora. Note the short stone pillar at the left corner of the garage. It is a milestone marking eight miles from Camden on the pike. (Courtesy of William W. Leap.)

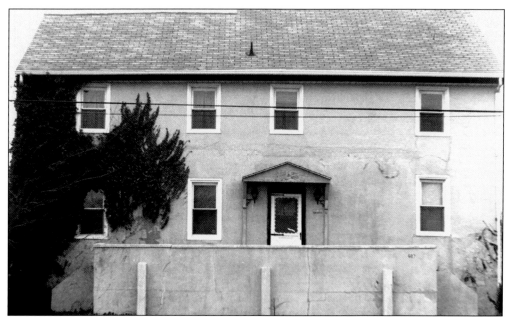

DANIEL HILLMAN HOUSE, GLENDORA, C. 1960. As the popularity of the automobile grew, so did the need for road improvements. The narrow wagon roads were widened, and both their surfaces and their curves smoothed. Compare this image with that on page 11. The front of this grand plantation house has been squeezed by the widened pike. The facade bears marks from renovations including removing the front porch and original entrance. Today the encroaching ivy has been removed, and the stucco exterior has been updated. (Courtesy of Gloucester Township Historical Society.)

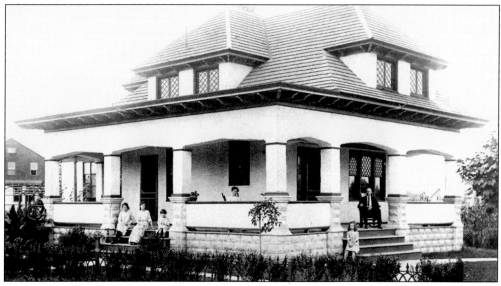

RAINIER RESIDENCE, BLACKWOOD, C. 1920. Newer and larger homes were built off the Black Horse Pike, such as the home of Lehman Rainier, which stands on West Railroad Avenue in Blackwood. Rainier (right) sits on his spacious porch with his family, who are, from left to right, Sara Rainier-Bakley, Mildred Rainier-Gardner, Leona Rainier-Priest, wife Lizzie Rainier, and Elizabeth Rainier-Reynolds. (Courtesy of Jack Simpson.)

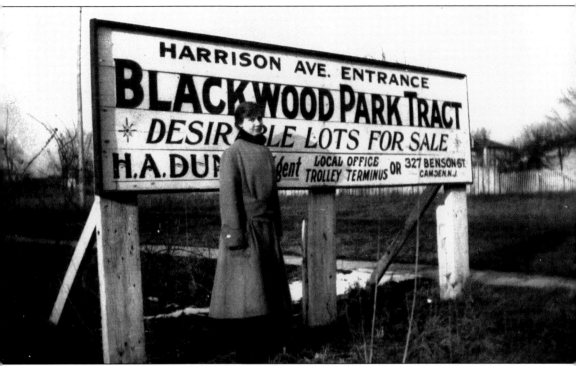

REAL ESTATE FOR SALE, BLACKWOOD, C. 1920. Automobile ownership eliminated the need to rely on public transportation or a healthy walk to work and suburban development burgeoned. Real estate developers sought to entice buyers to their spacious lots in the pike towns. H. A. Dunk preserved many important images on postcards in the early 20th century. He was also a real estate agent with "desirable lots for sale" in Blackwood. The trolley indicated on his billboard is the line between Woodbury and Blackwood. (Courtesy of the Gloucester Township Historical Society.)

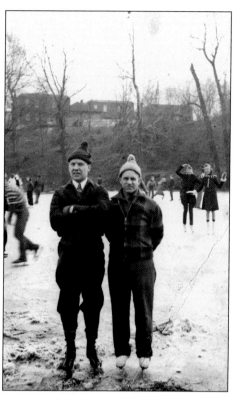

**ELDRIDGE'S MILL POND, HADDON HEIGHTS c. 1940.** Recreational outlets abounded in the pike communities. Frozen ponds and cranberry bogs were a source of winter fun. Dan Szymanski (left) and Frank Basinski skate on the frozen mill pond at Eldridge's farm on the Black Horse Pike in Haddon Heights. The farm was bisected by the construction of Interstate 295. Construction of the highway, which runs parallel to the New Jersey Turnpike, began in 1948. (Courtesy of William W. Leap.)

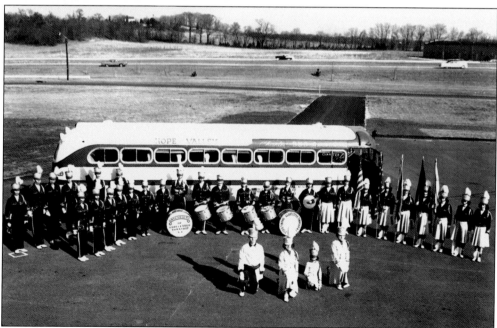

**BRIGADIERS DRUM & BUGLE CORPS OF GLOUCESTER TOWNSHIP, GLENDORA, c. 1958.** As communities developed, organized activities took shape including athletic teams, scout troops, and musical groups. The Brigadiers performed in township parades and at a variety of functions. (Courtesy of Bette Knipe.)

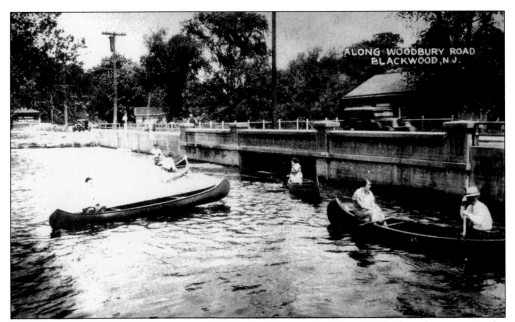

BLACKWOOD LAKE, BLACKWOOD, C. 1940. Residents and visitors flocked to the water in the warmer months, too. Canoeing on Blackwood Lake had been a popular form of recreation since the earliest vacationers visited the lake and other settlements along Big Timber Creek. (Courtesy of Jack Simpson.)

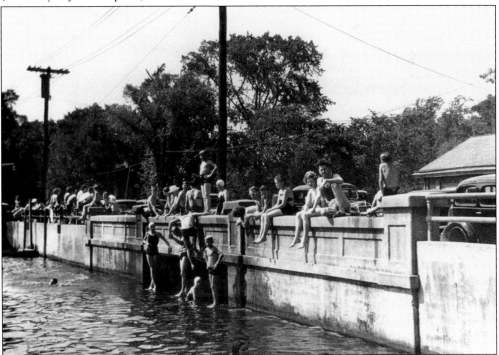

DIVERS ON THE WOODBURY ROAD BRIDGE, BLACKWOOD, C. 1940. An alternative to a trip to the beach, and the only remedy for a hot, humid summer's day is a dip in Blackwood Lake, as evidenced by the traffic backed up on the bridge. (Courtesy of Jack Simpson.)

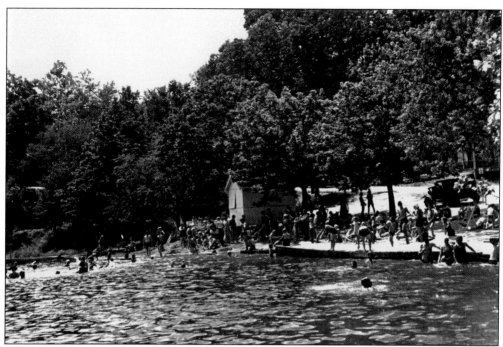

BLACKWOOD LAKE, WASHINGTON TOWNSHIP, C. 1940. This view shows the Washington Township side of the lake. Thousands traveled to Blackwood and Grenloch Lakes in the summer. More than swimming and canoeing awaited visitors. Annual water carnival celebrations included music and dancing. Prizes were awarded to the best decorated boats and canoes. (Courtesy of Jack Simpson.)

THE WOOD FAMILY, BLACKWOOD, C. 1940. The population of Gloucester Township had grown to 5,820 in 1930. Increasing numbers of weekenders visited Blackwood Lake, including the Wood family of Woodbury. A trolley line between Blackwood and Woodbury was in operation until 1934. The short ride was perfect for day-trippers. (Courtesy of Suzanne E. Chamberlin and Deborah L. Wood.)

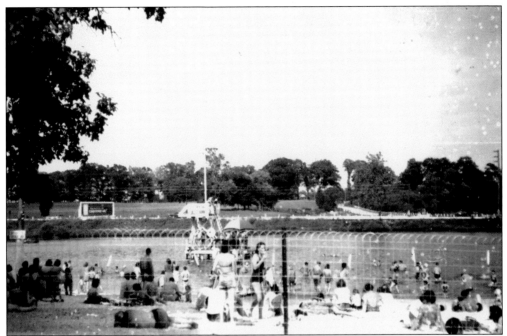

BLACKWOOD LAKE, BLACKWOOD, C. 1955. The lake remained a popular retreat even after the trolley line ceased operation and until the lake was condemned. The billboard in the distance (left) is advertising General Electric's "conditioned air." (Courtesy of Suzanne E. Chamberlin and Deborah L. Wood.)

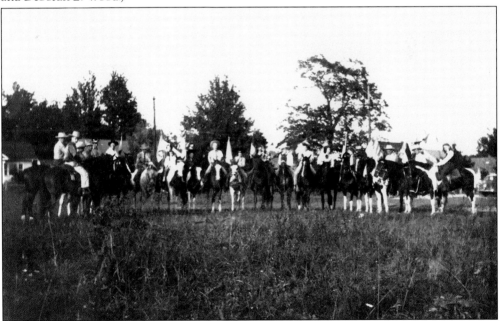

WILLIAMSTOWN RIDING CLUB, WOODBURY, 1945. Members of the Williamstown Riding Club are saddled up and ready to ride in the V-J Day parade in Woodbury. The club met and performed their exhibitions at a field behind their leader's house between Clinton Avenue and the Black Horse Pike in Williamstown. (Courtesy of the Gloucester County Historical Society.)

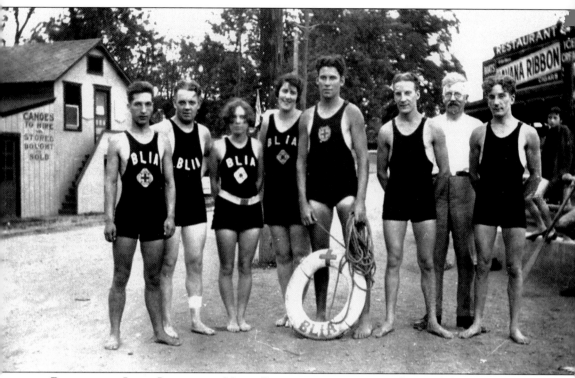

**BLACKWOOD LAKE LIFEGUARD UNIT, BLACKWOOD, C. 1940.** The need for public services continued to change in response to a community's needs. These unidentified Blackwood Lake lifeguards stand ready to keep summer bathers safe. They are members of the Blackwood Lake Improvement Association (BLIA), sponsors of the annual carnival on the lake. In 1921, the BLIA donated $919.66 to Blackwood Fire Company No. 1 towards the construction of their first permanent building. (Courtesy of Jack Simpson.)

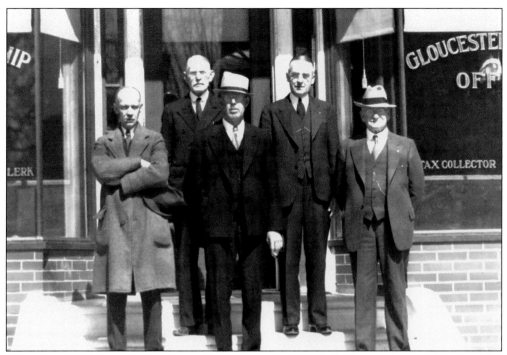

GLOUCESTER TOWNSHIP OFFICIALS, BLACKWOOD, C. 1940. Public services require oversight, including the collection of taxes. Pictured in front of the Gloucester Township offices on the Black Horse Pike are, from left to right, Roland C. Baer (Gloucester Township clerk), Farest North (truant officer), Schuyler C. Godfrey (Gloucester Township clerk), William L. Smith (committeeman), and Abram J. Severns (committeeman). (Courtesy of the Gloucester Township Historical Society.)

GLOUCESTER TOWNSHIP DOG REGISTRATION PROGRAM, BLACKWOOD, 1910. This lucky pooch vacationed with his owners on Blackwood Lake in 1955, but generations of dogs before him were not so lucky. In 1910, stray dogs in Gloucester Township were numerous enough to warrant the employment of four dog catchers. Frustration with the dogs' preying on small farm animals soon grew to fear as a rabid dog ran loose in Grenloch just as church was letting out on a Sunday. The township council quickly passed an ordinance that all owners must register their dogs. (Courtesy of Suzanne E. Chamberlin and Deborah L. Wood.)

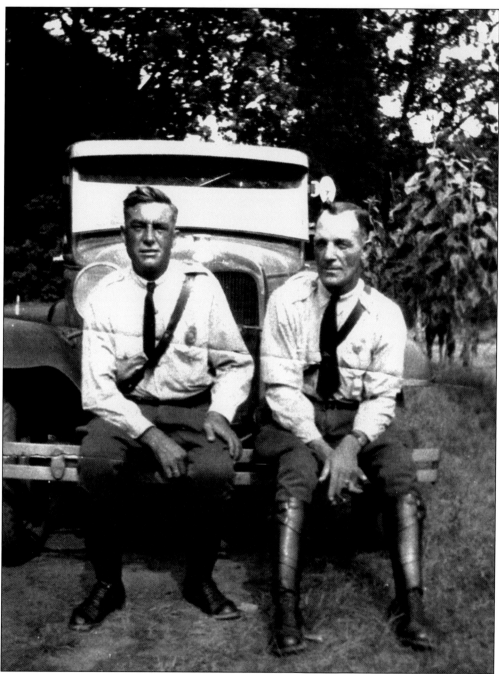

GLOUCESTER TOWNSHIP POLICE FORCE, BLACKWOOD, C. 1932. More than just the dog population needed policing. A burgeoning population and increasing traffic issues prompted township officials to appoint Chief William Ritter (right) to his post in 1925. Although he oversaw the traffic officers hired in 1920, no other police officers were hired until the township budget could accommodate their salaries in 1927. Pictured with Chief Ritter is officer Walter Wilkie. (Courtesy of William W. Leap.)

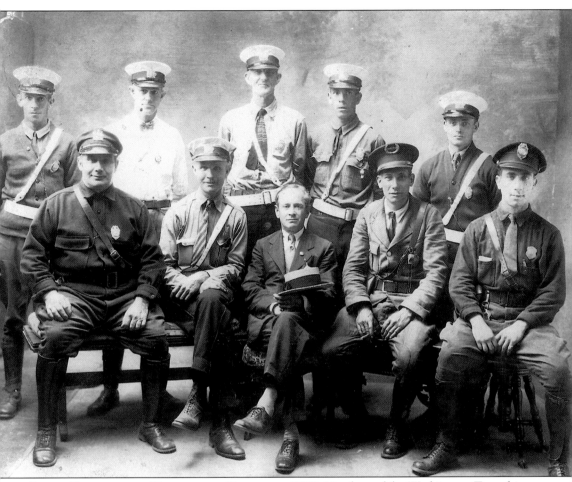

**POLICE DEPARTMENT, WASHINGTON TOWNSHIP, 1920.** Members of the Washington Township Police Force, including its part-time staff, are pictured here. From left to right are (first row) Joseph Kuckler, Charles S. Quay (chief), Paul Kutler (police clerk), Harry Winart, and William Kuckler; (second row) Elmer B. Williams, Rudolph Fields, John King, Edward Williams, and Harry Sloan. (Courtesy of the Gloucester County Historical Society.)

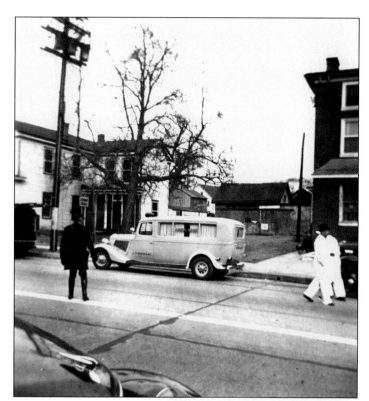

**GLENDORA AMBULANCE, BLACKWOOD, C. 1944.** While automobiles remained affordable, the cost of specialized vehicles often applied pressure to the tight budgets of service organizations. While a new ambulance might have been out of financial reach, a used vehicle fit the budget. Glendora's first ambulance unit readies its converted hearse for the World War II victory parade along the pike through Blackwood near the current site of the library. (Courtesy of Jack Simpson.)

**BLENHEIM FIRE DEPARTMENT VEHICLES, BLACKWOOD, C. 1944.** The Blenheim Fire Company and Air Raid Unit similarly made good use of a 1928 REO Speedwagon. Designed by Ransom Eli Olds and built by the REO Motor Car Company of Lansing, Michigan, in the early 20th century, the flatbed trucks were very powerful and could carry heavy loads. They were often outfitted as fire engines. The 1970s rock band took its name from the name of the vehicle. (Courtesy of Jack Simpson.)

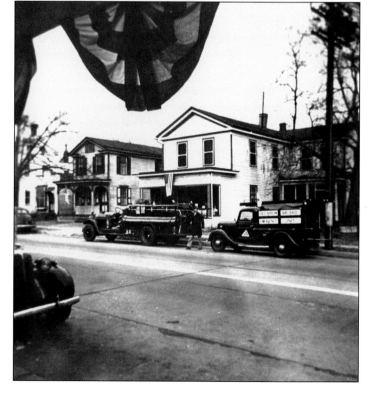

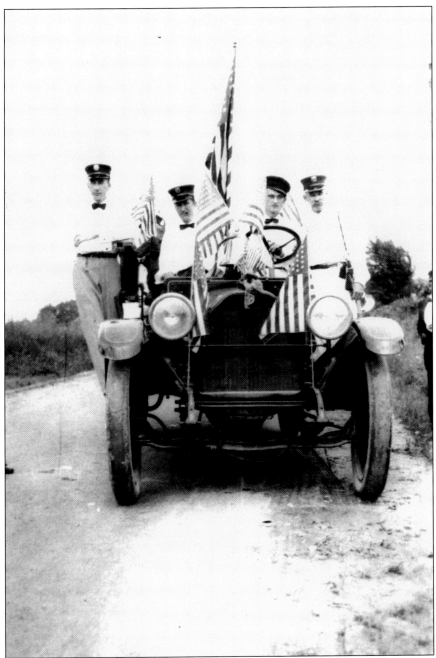

**BLACKWOOD FIRE COMPANY, BLACKWOOD, C. 1919.** Hope Fire Company No. 1 of Blackwood was established on December 26, 1893. The company's first equipment was drawn and operated by the men of the company. It was later converted to a horse-drawn vehicle. The first motorized truck, the 1916 four-cylinder Studebaker pictured here, was purchased by E. Frank Pine Sr. in 1917, the same year the company changed its name to the Blackwood Fire Company No. 1. Pictured on the truck decorated for an Independence Day celebration are, from left to right, Frank Keith, Willis Harrison, unidentified, and Bob Montgomery. (Courtesy of the Gloucester Township Historical Society.)

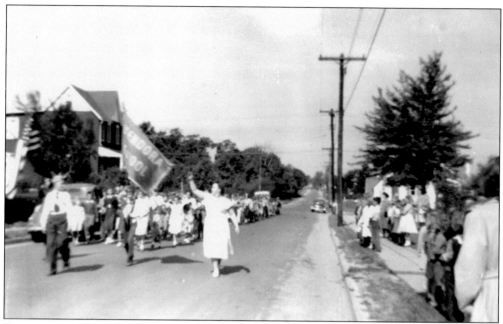

**DECORATION DAY, GLENDORA, 1953.** A community's school is often its greatest source of pride. Here schoolchildren are led by their teacher through town on Decoration Day in 1953. Decoration Day was renamed Memorial Day in 1967. When the children arrived at the Glendora School, ceremonies were held to honor those who died in our nation's service. (Courtesy of Bette Knipe.)

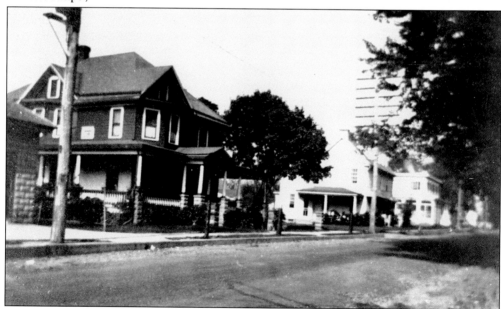

**BLACK HORSE PIKE AND CLEVELAND AVENUE, BLACKWOOD, C. 1940.** Despite threats by flood or pollution, Big Timber Creek development continued in Black Horse Pike communities and resulted in the pike's modernization. The roadway was widened and paved. Sidewalks replaced the front lawns of the older dwellings. Electric streetlights replaced gas lights in 1923. (Courtesy of Jack Simpson.)

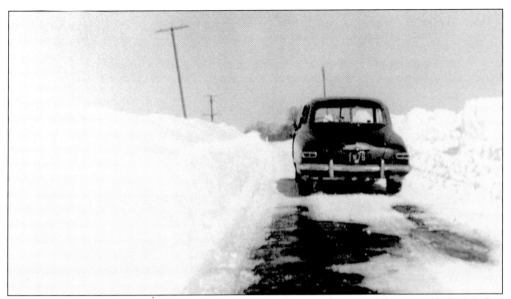

BLIZZARD AFTERMATH, BLACKWOOD, 1958. A modern roadway is still no match for Mother Nature. In the aftermath of the February 16, 1958, blizzard, National Guard tanks were called in to break through six-foot drifts and plow the Black Horse Pike and other major roadways as snow-clearing equipment was not yet commonplace. (Courtesy of Jack Simpson.)

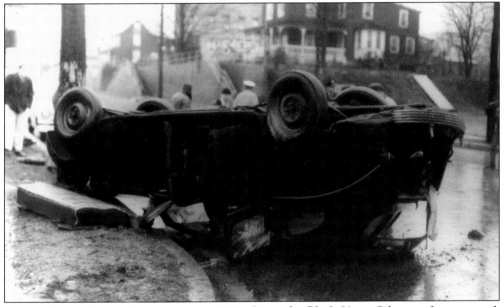

DEAD MAN'S CURVE, GLENDORA, C. 1940. Since the Black Horse Pike was first surveyed, the curve, slope, and odd intersection of roadways where the pike crosses Big Timber Creek at the border of Glendora and Chews Landing has been dangerous enough to earn the name "Dead Man's Curve." By 1929, this portion of the pike had been straightened out and graded to eliminate the steep hill and to bypass the curve into Chews Landing. The "new" section of the pike continues in a straight line between Glendora and Blackwood, while Dead Man's Curve swings through Chews Landing to the Old Black Horse Pike. (Courtesy of the Gloucester Township Historical Society.)

**BOARDWALK, ATLANTIC CITY, 1944.** Atlantic City has been an attraction since even before its first rooming house was built in the mid-1800s, and by the end of World War II, it was finally accessible via the Black Horse Pike. Paving of the pike began in the 1920s, and the route was extended to the shore in 1931, making the Black Horse Pike a true city-to-shore route at last. On summer weekends, the pike was jammed with excursionists like newlyweds Viola and Bud Byrne heading to or from the boardwalk. (Courtesy of Pat Rappucci.)

*Four*

# THE EXPRESSWAY
# AND THE BRIDGE

While the need for fixed crossings of the Delaware River had been recognized as early as 1818, no one accurately anticipated the volume of vehicular traffic that would begin to cross the Benjamin Franklin Bridge when it opened in 1926.

A second crossing between Camden and Philadelphia was immediately planned and proposed in the form of a tunnel. A number of factors were considered, including obstruction of shipping lanes, urban blight, and also the growing system of roads and highways. The idea of a tunnel was abandoned in favor of the sagacious choice—a second bridge.

Officials realized that moving large numbers of vehicles over a modern bridge and onto old roadways through small towns would not solve transportation issues facing the expanding urban region. When plans for the Walt Whitman Bridge were announced in 1953, the then-proposed North-South Freeway (Route 42) project suddenly became a top priority.

The Walt Whitman Bridge opened in 1957 and the North-South Freeway was completed in 1959 providing expressway access as far south as the junction with U.S. Route 322 in Williamstown. The high-speed route dramatically changed traffic patterns, and therefore commerce, on the Black Horse Pike through Camden County. The Atlantic City Expressway opened in 1965, extending high-speed travel through Atlantic County and completing the city-to-shore route.

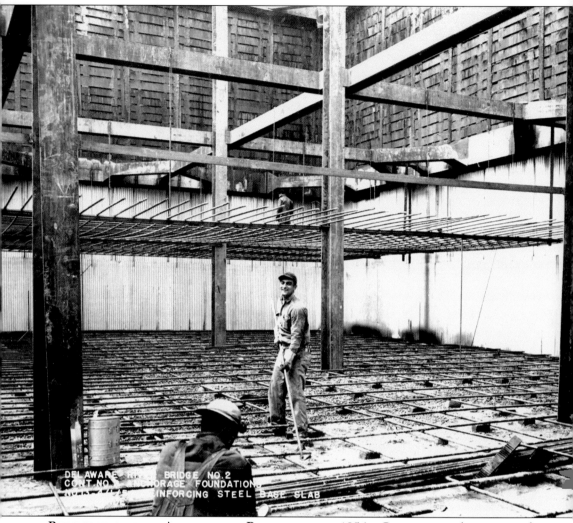

**Reinforcing the Anchorage, Philadelphia, 1954.** Construction began on the Walt Whitman Bridge on August 1, 1953. Concrete anchorages were dug in south Philadelphia and Gloucester City. On the Philadelphia side, part of a railroad yard was relocated to make way for the bridge and its approach. In New Jersey, the course of the Newton Creek was moved, and the old creek bed filled in. Each anchorage is 60 feet deep, 200 feet long, 120 feet wide, and 130 feet above the ground. (Courtesy of the Delaware River Port Authority.)

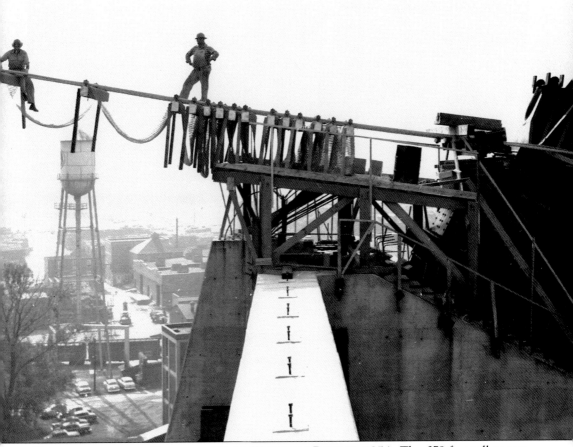

**Constructing the Catwalk, Walt Whitman Bridge, 1954.** The 378-foot-tall towers were constructed using 10,215 tons of structural steel. Some sections of the bridge towers were fabricated and assembled at the Bethlehem Steel plant in Pottstown, Pennsylvania, and moved to the construction site. In this image, iron workers atop the towers construct the catwalk upon which the cable spinners will work. (Courtesy of the Delaware River Port Authority.)

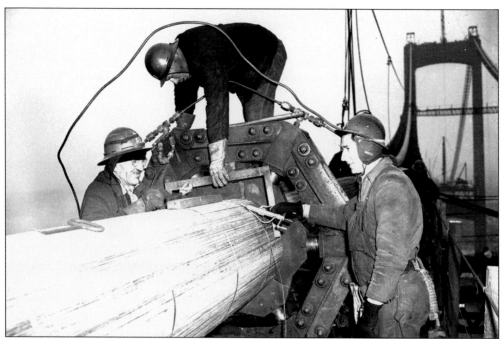

CABLE SPINNING, WALT WHITMAN BRIDGE, 1955. Each of the bridge's main support cables is made up of 60,000 miles of wire. Bundles of 0.2-inch-diameter wire are spun together to form the thick cables pictured in this image. Each is precisely 23.125 inches in diameter. (Courtesy of the Delaware River Port Authority.)

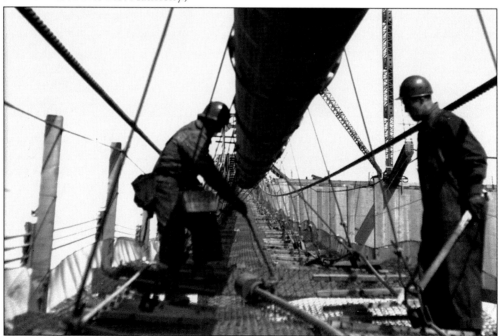

CABLE WORKERS, WALT WHITMAN BRIDGE, 1955. Two main cables, each 3,845 feet long, support the bridge. At mid-span, the roadway is 150 feet above the Delaware River. (Courtesy of the Delaware River Port Authority.)

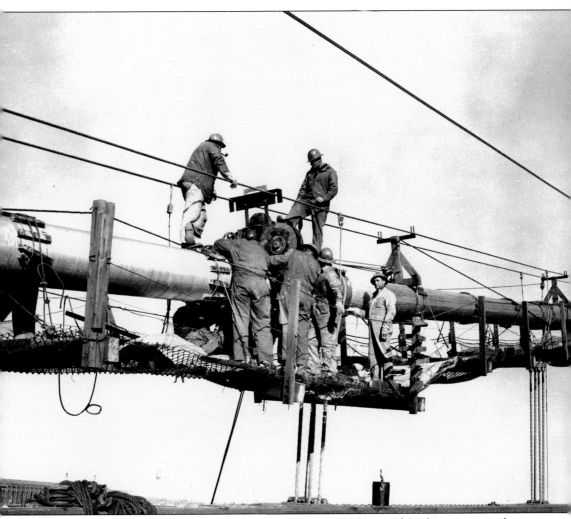

**FINISHING THE CABLES, WALT WHITMAN BRIDGE, 1955.** Nerves of steel were required to work on cables of steel. Safety measures have improved radically in the last 50 years for workers performing maintenance on bridges. In this image, precariously situated workers put the finishing touches on the cables that will soon suspend the bridge's trusses and roadway. (Courtesy of the Delaware River Port Authority.)

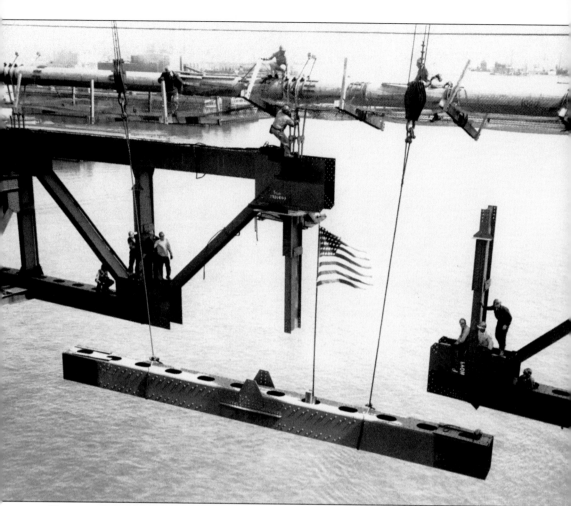

**BOTTOM CHORD OF STIFFENING TRUSS, WALT WHITMAN BRIDGE, 1956.** The last section of stiffening truss is hoisted into place at the bridge's mid-span on June 20, 1956. The roadway was constructed of 11,733 tons of structural steel. (Courtesy of the Delaware River Port Authority.)

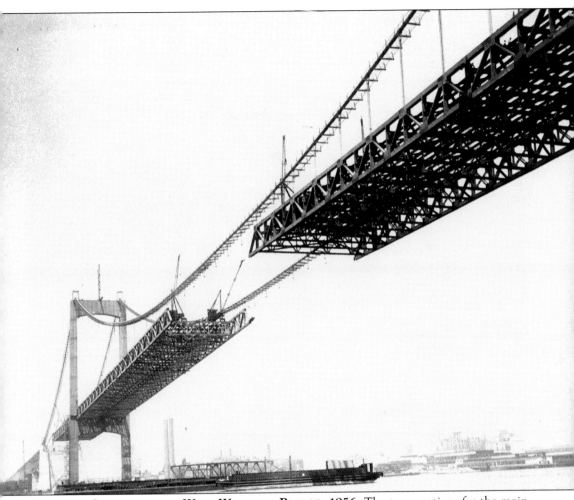

**ROADWAY CONSTRUCTION, WALT WHITMAN BRIDGE, 1956.** The truss sections for the main span of the bridge were positioned by barges on the river and then lifted by cranes at the roadway's edge. The main span of the bridge is 2,000 feet long and is seven traffic lanes wide. (Courtesy of the Delaware River Port Authority.)

**WALT WHITMAN BRIDGE DEDICATION, MID-SPAN, 1957.** The Walt Whitman Bridge cost $90 million to build. Eight workers lost their lives. After a steelworkers strike delayed the final stages of construction, the bridge was dedicated on May 15, 1957. These dignitaries are, from left to right, New Jersey governor Robert B. Meyner; Charles Smith, auditor general of Pennsylvania; James Baney, vice chairman of the Delaware River Port Authority; and J. William Markeim, chairman of the Delaware River Port Authority. (Courtesy of the Delaware River Port Authority.)

**WALT WHITMAN BRIDGE, 1957.** Opening ceremonies were held on the bridge on May 15, 1957. The bridge was not yet open to vehicular traffic, and several thousand attended the official festivities. (Courtesy of the Delaware River Port Authority.)

**OPENING DAY ON THE WALT WHITMAN BRIDGE, 1957.** On May 15, 1957, the bridge celebrations included opening the roadway to pedestrians from 12:00 p.m. to 6:00 p.m. before vehicular traffic would begin to cross the span at midnight. (Courtesy of the Delaware River Port Authority.)

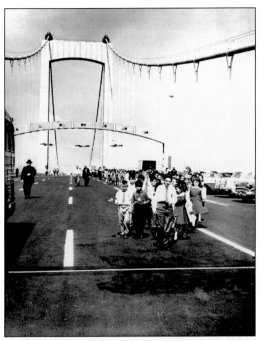

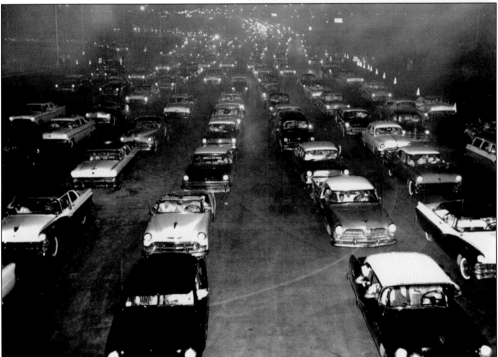

**CROSSING THE WALT WHITMAN BRIDGE, 1957.** This is one traffic jam no one was unhappy to be stuck in. All seven lanes are packed with vehicles waiting to cross the bridge at 12:01 a.m. on May 16. More than 3,000 vehicles crossed the bridge in the first hour. More than 30,000 vehicles traveled the span in the first 24 hours. On July 3, 1990, the one billionth vehicle crossed the Walt Whitman Bridge. (Courtesy of the Delaware River Port Authority.)

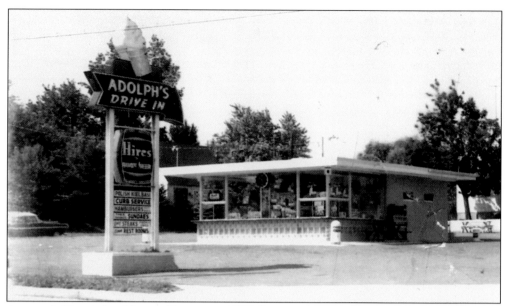

**ADOLPH'S DRIVE-IN, MOUNT EPHRAIM, 1955.** Despite the completion of the Walt Whitman Bridge and the North-South Freeway, business remained good at favorite eateries such as Adolph's Drive-In on the Black Horse Pike. For 25 years, owners Adolph and Helen Lubas served traditional roadside goodies such as cheesesteaks, subs, soft ice cream, and monster shakes. (Courtesy of Sue Carr.)

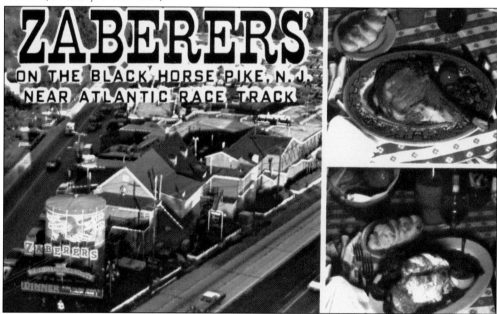

**ZABERER'S RESTAURANT, ATLANTIC CITY, C. 1960.** Expressways may make for a quicker trip, but the quality of roadside dining is sacrificed. Fast food will never replace the likes of drive-ins, diners, and sit-down restaurants. One of the great traditions for Jersey Shoregoers was to dine at Zaberer's on the Black Horse Pike, a favorite place for food and drinks, famous for its piled high entrees and "Zaberized" cocktails and desserts. Lucky vacationers might even glimpse celebrities headlining at the nearby hotels and clubs. (Courtesy of Mark Plocharski.)

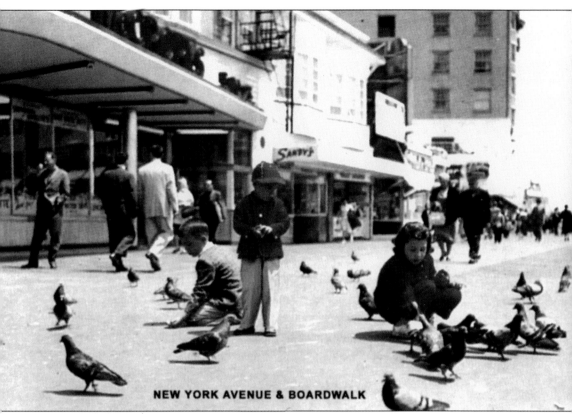

NEW YORK AVENUE & BOARDWALK

BOARDWALK AT NEW YORK AVENUE, ATLANTIC CITY, C. 1960. When the Atlantic City Expressway was completed in 1965, traffic did not flow into Atlantic City at the rate many had anticipated. The commercial airline business was just taking off, and Americans' wanderlust was in high gear. In just a few more years, the oil crisis hit hard, and gas was no longer inexpensive or readily available. The expressway was beginning to look like a rather foolish enterprise at its cost of nearly $40 million. But when the Casino Gambling Referendum passed legislation in 1976, Atlantic City underwent a slow and steady revitalization. The Atlantic City Expressway is busy again, and even traffic on the Black Horse Pike picks up in the summer months. (Author's collection.)

NITRO GIRL, HILLTOP, 2007. Those who travel the expressways in favor of the slower Black Horse Pike will never experience sites such as Nitro Girl. She is a revamped Uniroyal Gal who has been a fixture at Werbany Tire Town since 1965. Uniroyal Gals were sculpted in the likeness of then–First Lady Jacqueline Kennedy. Various surviving Uniroyal Gals around the country have been painted to satisfy their owners' preferences, including as a blonde waitress in Blackfoot, Idaho, and a cheerleader for the Lamesa, Texas, Tornados. Only in Hilltop is she the patriotic superhero Nitro Girl. The 18-foot tall icon was made over in 2007 and is an example of what makes America's local roads such as the Black Horse Pike unique. (Courtesy of Werbany Tire Town.)

# BIBLIOGRAPHY

Cunningham, John T. *New Jersey: America's Main Road*. Revised Edition. Andover, New Jersey: Afton Publishing Company, 1976.

Dorwart, Jeffery M. and Philip English Mackey. *Camden County, New Jersey 1616-1976: A Narrative History*. Camden: Camden County Cultural and Heritage Commission, 1976.

Fox, Edward E. III, Robert Thompson, and Jo Ann Field Kaitz. *The History of the Township of Gloucester 1695 to 2003*. Runnemede: Colour Printing, 2005.

Leap, William W. *The History of Runnemede, New Jersey, 1626-1976*. Runnemede: Borough of Runnemede, New Jersey, 1981.

Prowell, George R. *The History of Camden County, New Jersey*. Philadelphia: L. J. Richards and Company, 1886. Reprinted 1974.

Welsch, Joe. *American Railroad: Working for the Nation*. St. Paul, Minnesota: MBI Publishing Company, 2006.

www.aclink.org/PARKS/mainpages/historic_weymouth.asp

www.agmuseum.com/1918_fordson_tractor.htm

www.atlantic-city-online.com/history/history.shtml

www.blackwoodfire.org/history.htm

www.chewslandingfire.org/history.php

www.drpa.org/drpa/drpa_history.html

www.gloucestertownshipschools.org/schools/GLD/history.html

www.phillyroads.com

www.lansingpolice.com/site/History/REO.htm

www.sjrail.com

www.stjohns1789.org/history.html

www.rodsandwheels.com/emagazine.php?flag=show_story&toc_id=585

www.roadsideamerica.com/tnews/NewsItemDisplay.php?Tip_AttrId==16083

www.usaprofiles.com/manufacturers/0000000576.htm

www.weymouthnj.org/history_colonial_days.htm

# DISCOVER THOUSANDS OF LOCAL HISTORY BOOKS FEATURING MILLIONS OF VINTAGE IMAGES

Arcadia Publishing, the leading local history publisher in the United States, is committed to making history accessible and meaningful through publishing books that celebrate and preserve the heritage of America's people and places.

Find more books like this at
**www.arcadiapublishing.com**

Search for your hometown history, your old stomping grounds, and even your favorite sports team.

Consistent with our mission to preserve history on a local level, this book was printed in South Carolina on American-made paper and manufactured entirely in the United States. Products carrying the accredited Forest Stewardship Council (FSC) label are printed on 100 percent FSC-certified paper.

MADE IN THE

USA